50 NEW YORK ARTISTS

CHRONICLE BOOKS • SAN FRANCISCO

50 NEW YORK ARTISTS

A CRITICAL SELECTION OF PAINTERS AND SCULPTORS WORKING IN NEW YORK

BY RICHARD MARSHALL

WITH PHOTOGRAPHS OF THE ARTISTS
BY ROBERT MAPPLETHORPE

*Library of Congress Cataloging in
Publication Data*:
Marshall, Richard, 1947–
50 New York artists
1. Art, American—New York (N.Y.)
2. Art, Modern—20th century—New
York (N.Y.) 3. Artists—New York
(N.Y.)—Portraits. I. Mapplethorpe,
Robert. II. Title. III. Title: Fifty New
York artists.
N6535.N5M28 1986
759.147'1 86-17521
ISBN 0-87701-403-5
ISBN 0-87701-397-7 (soft)

Acknowledgments:
The collaborators of this book owe
special gratitude to the following:
Deborah Felstehausen, editorial
assistant to Richard Marshall;
Tina Summerlin, studio manager
for Robert Mapplethorpe.

Chronicle Books
One Hallidie Plaza
San Francisco, California 94102

Photographic credits:
Gregory Amenoff: Courtesy Robert Miller Gallery.
Richard Artschwager: Courtesy Leo Castelli Gallery
Jennifer Bartlett: eeva-inkeri.
Lynda Benglis: Courtesy Paula Cooper Gallery.
Louise Bourgeois: Courtesy Robert Miller Gallery.
Louisa Chase: D. James Dee.
Sandro Chia: Courtesy Sperone Westwater.
Francesco Clemente: Courtesy The Museum of Modern Art.
Chuck Close: Courtesy The Pace Gallery.
Willem de Kooning: Courtesy Xavier Fourcade, Inc.
Mark di Suvero: Courtesy of the artist and Oil & Steel Gallery.
Richard Estes: Courtesy of the artist.
R. M. Fischer: Courtesy Baskerville + Watson.
Eric Fischl: Courtesy Mary Boone Gallery.
Janet Fish: Courtesy Robert Miller Gallery.
Jedd Garet: Courtesy Robert Miller Gallery.
Leon Golub: Courtesy Barbara Gladstone Gallery.
Nancy Graves: Courtesy M. Knoedler & Co.
Red Grooms: Courtesy Marlborough Gallery, Inc
Keith Haring: Ivan Dalla Tana.
Bryan Hunt: Courtesy Blum Helman Gallery.
Jasper Johns: Courtesy Leo Castelli Gallery.
Donald Judd: Dorothy Zeidman.
Alex Katz: Courtesy Marlborough Gallery, Inc.
Ellsworth Kelly: Courtesy Blum Helman Gallery.
Robert Kushner: D. James Dee.
Roy Lichtenstein: Dorothy Zeidman.
Robert Longo: Metro Pictures.

Robert Mangold: eeva-inkeri.
Robert Mapplethorpe: Courtesy Robert Miller Gallery.
Brice Marden: Bill Jacobson.
Malcolm Morley: Courtesy Xavier Fourcade, Inc.
Robert Moskowitz: Andrew Moore
Elizabeth Murray: Courtesy of Geoffrey Clements.
Louise Nevelson: Courtesy The Pace Gallery.
Isamu Noguchi: Courtesy Isamu Noguchi Garden Museum.
Philip Pearlstein: Courtesy Hirschl & Adler Modern.
Judy Pfaff: Courtesy Holly Solomon Gallery.
James Rosenquist: Courtesy Leo Castelli Gallery.
Susan Rothenberg: Courtesy Willard Gallery.
David Salle: Zindman/Fremont.
Kenny Scharf: Ivan Dalla Tana.
Julian Schnabel: Beth Phillips.
George Segal: Allan Finkelman.
Richard Serra: Courtesy Leo Castelli Gallery.
Joel Shapiro: D. James Dee.
Cindy Sherman: Courtesy of the artist.
Andy Warhol: Glenn Steigelman.
Jackie Winsor: Courtesy Paula Cooper Gallery.
Terry Winters: Courtesy Sonnabend Gallery.

*The statements have been written and
supplied by the artists for this book. The
following list applies to those statements
for which additional acknowledgment is
due:*
Francesco Clemente: Quoted in Paul Gardner's "Francesco Clemente: Gargoyles, Goddesses and Faces in the Crowd," *Art News*, March 1985.
Jasper Johns: Quoted in April Bernard and Mimi Thompson's "Johns On . . . ," *Vanity Fair*, February 1985. ©1985 Condé Nast Publications Inc.
Donald Judd: Quoted in exhibition catalogue *Documenta 7* (Kassel, West Germany: Druck Verlag GmbH), 1982.
Ellsworth Kelly: Quoted in exhibition catalogue *Ellsworth Kelly* (New York: Leo Castelli Gallery, and Los Angeles: Margo Leavin Gallery), 1984.
Brice Marden: Quoted in exhibition catalogue *Brice Marden: Paintings, Drawings and Prints 1975–1980* (London: White-chapel Art Gallery), 1981.
Isamu Noguchi: Quoted in Sam Hunter's exhibition catalogue *Isamu Noguchi* (New York: The Pace Gallery), 1980.
Richard Serra: Quoted in exhibition catalogue *1985 Carnegie International* (Pittsburgh: Museum of Art, Carnegie Institute), ©1985 Museum of Art, Carnegie Institute.
Cindy Sherman: Quoted in exhibition catalogue *Documenta 7* (Kassel, West Germany: Druck Verlag GmbH), 1982.
Andy Warhol: Quoted in Achille Bonito Oliva's *Diaoghi d'artista* (Milan: Electra Editrice), 1984.

CONTENTS

7 *Introduction*

16 Gregory Amenoff

18 Richard Artschwager

20 Jennifer Bartlett

22 Lynda Benglis

24 Louise Bourgeois

26 Louisa Chase

28 Sandro Chia

30 Francesco Clemente

32 Chuck Close

34 Willem de Kooning

36 Mark di Suvero

38 Richard Estes

40 R. M. Fischer

42 Eric Fischl

44 Janet Fish

46 Jedd Garet

48 Leon Golub

50 Nancy Graves

52 Red Grooms

54 Keith Haring

56 Bryan Hunt

58 Jasper Johns

60 Donald Judd

62 Alex Katz

64 Ellsworth Kelly

66 Robert Kushner

68 Roy Lichtenstein

70 Robert Longo

72 Robert Mangold

74 Robert Mapplethorpe

76 Brice Marden

78 Malcolm Morley

80 Robert Moskowitz

82 Elizabeth Murray

84 Louise Nevelson

86 Isamu Noguchi

88 Philip Pearlstein

90 Judy Pfaff

92 James Rosenquist

94 Susan Rothenberg

96 David Salle

98 Kenny Scharf

100 Julian Schnabel

102 George Segal

104 Richard Serra

106 Joel Shapiro

108 Cindy Sherman

110 Andy Warhol

112 Jackie Winsor

114 Terry Winters

117 *Artists' New York Representatives*

A discussion of New York art is often synonymous with discussing all of American, or even international, art. Although New York is not the only art-producing center in the United States, it is so influential intellectually, creatively, and commercially that it dominates numerous aspects of twentieth-century living, especially the arts. In addition to attracting, stimulating, and sustaining one of the largest artistic populations in the world, New York also acts as a nucleus for exhibiting and selling work by artists from other regions in the United States and throughout Europe. New York remains the largest arena for the evaluation and judgment of art. The New York City Department of Cultural Affairs estimates that there are currently more than sixty thousand visual artists in the city, not including commercial artists; a current guide lists over six hundred art galleries, the majority of them specializing in contemporary works.

It is obvious that limiting a selection of New York artists to fifty is too restricting to represent adequately the vitality and breadth of the current art community; hundreds of artists could be considered for inclusion in this book. Consequently, this selection is not comprehensive or definitive, but a survey of artists that conveys a sense of the quality and diversity of contemporary art being produced in New York City. The choices included here are based on critical and qualitative evaluations, with consideration given to a continuity of aesthetic contribution, and the introduction of new artistic forms and concepts, primarily determined by work of the last five years. Although fifty is a relatively small number (and some important artists declined to participate in this publication), the artists appearing here represent significant aesthetic attitudes and varying forms of expression, offering a compact and abbreviated view of recent art in New York.

This selection encompasses artists of all ages and work produced in all media and styles. The fifty artists presented range in age from twenty-eight to eighty-six years old, and represent all stages of career status—from Willem de Kooning, whose first one-man exhibition was held in New York in 1948 at the age of forty-four, to Keith Haring, whose first New York show was in 1981 at twenty-three years old. The artworks reproduced have been limited to pieces made since 1980 in order to present a sampling of very recent work and convey a sense of New York art in the 1980s. The senior artists—Louise Bourgeois, Willem de Kooning, Louise Nevelson, and Isamu Noguchi—have been working for as many as fifty years. Although the last five years is a relatively short segment of their careers, their recent work possesses the same strength and originality that brought

7

them international recognition decades ago. Conversely, some of the youngest artists, born since 1950, have been visible only five years. Keith Haring, Kenny Scharf, Jedd Garet, Robert Longo, and Cindy Sherman demonstrate the evolutionary aspect of current art and acknowledge the origination and transformation of attitudes and expression. However, the majority of artists in the book are members of the middle generation and have been working ten to twenty years—mid-career artists whose works exhibit an ongoing confidence and strength in both concept and execution.

Of these fifty New York artists, only twelve were actually born in New York; the balance were born in a total of fifteen other states and eight countries. Most moved to New York expressly to begin their careers as professional artists, confirming the city's appeal as a creative center that draws, nurtures, inspires, and recognizes artistic expression. This book also displays the full range of media that artists employ—painting, sculpture, photography, drawing, and combinations and variations of each. A review of the contents reveals that there are almost twice as many painters as sculptors included, which reflects the continuing dominance of two-dimensional work. This also suggests that sculpture, a difficult discipline, tends to have a slower maturation and recognition than painting. Photographic imagery and proc-

esses, long recognized as significant aspects of contemporary art, are used in various ways by a number of artists as diverse as Chuck Close, Richard Estes, Robert Mapplethorpe, David Salle, Cindy Sherman, and Andy Warhol to investigate the nature of representation, reproduction, and the influence of mass media on the fine arts.

Accompanying each artist's portrait and artwork is a statement that offers his or her personal insights and artistic concerns. These comments, written specifically for this book or revised versions of previously made statements, allow the reader a more personalized glimpse into the process of art making. In a few instances, the artist wished to reprint statements that were appropriate to the work being reproduced. Given that an artist's chosen form of expression is visual rather than literary, a few chose not to make statements. In these cases, comments have been excerpted from previously published interviews.

The fifty artists provide a framework for a generalized discussion of many of the major art forms and aesthetic developments of the late twentieth century. The senior generation were all born around the first decade of the century and began exhibiting in New York in the 1930s and 1940s. They were all foreign born or raised—Louise Nevelson in Russia; Willem de Kooning in the Netherlands; Louise

Bourgeois in France; and Isamu Noguchi, who was born in California, raised in Japan, and studied in Paris. These artists were formed by a different milieu than their American-born counterparts, and their work serves as evidence of the continuation of a European influence in modern American art. Their work is academically based, figure directed in abstraction, and suggests the influence of European surrealism, which as exemplified by the paintings of Willem de Kooning, was translated into abstract expressionism in America. The emergence of abstract expressionism in New York following the end of World War II, and the international impact and attention it prompted, heralded the shift of the international art center from Europe to the United States. New York has maintained that dominance and influence, and subsequent waves of new and advanced artistic expression have continued to emanate from the city.

The appearance of pop art, first introduced by Jasper Johns in the mid-1950s with paintings of common symbols, reconfirmed New York's richness as a wellspring of new ideas. This new generation, whose work promoted an ironic glorification of popular culture, appeared with great force in New York—and was enthusiastically received in the national and international press. Roy Lichtenstein's comic book–inspired painting, Andy Warhol's depictions of popu-

lar personalities and products, and James Rosenquist's overblown, surreal handling of advertising imagery expounded a radical, new definition of art. An attitude toward subject matter related to pop art pervades the work of Richard Artschwager, Malcolm Morley, Red Grooms, and Richard Estes as well. Their work displays exaggerated, ironic, and often enigmatic references to contemporary culture. New approaches to portraiture and figurative painting also occupy a number of artists of this same generation. Their work reveals diverse variations on a traditional approach to realism that assimilates the current aesthetic mood. Men and women are the subjects of Leon Golub, George Segal, Alex Katz, and Philip Pearlstein, but the content and style of their painting and sculpture deals with human beings in distinctly contemporary political, urban, and social situations.

In the late 1950s and early 1960s, another shift in mainstream New York art emerged in the form of minimalism. The abstract painting and sculpture that characterized this development—as seen in the work of Donald Judd, Ellsworth Kelly, and Robert Mangold—minimizes or eliminates any associative content through the use of pure geometric form and pure color. These artists purge art of extraneous details, personal reference, and subjective

expression and deal only with formal elements of structure, color, edge, and surface. Richard Serra, Brice Marden, and Mark di Suvero, although slightly younger than the first-generation minimalists, are aesthetically linked to that movement, and subtly begin to reintroduce emotion and allusion (and, in the case of di Suvero, movement) into their work. While the sculpture and painting of these artists are abstract and geometrically based, there exists an expressive, gestural, and referential impact that marks a turn away from the rigidity of pure minimalism.

A more substantial break from the monochromatic, abstract, and reductive aspects of minimalism emerged in New York in the late 1960s and early 1970s with a generation of artists born around 1940. This type of postminimal expression first began in sculpture, which seemed to offer more options for experimentation in materials and forms. Of primary importance to these sculptors—Joel Shapiro, Jackie Winsor, Lynda Benglis, and Nancy Graves—was the apparent need to reinfuse sculpture with meaning and allusions to something outside itself, references to the human body, forms in nature, and organic phenomena.

Artists' rejection and violation of minimalist tenets, especially lack of subject matter and imagery, also emerged in New York painting in the early 1970s. A number of painters began to draw on various aspects of abstract expressionist, minimal, pop, conceptual, and realist art forms in order to reintroduce subject matter into painting. Pop and minimal art both reflect a cool detachment from the subject matter, but this younger generation of artists embraced a more personal, emotional, and psychological approach to imagery. The paintings of Jennifer Bartlett, Elizabeth Murray, and Susan Rothenberg wed the formal aspects of painting to an emotional, autobiographical expression. Chuck Close uses a geometrically repetitive technique to reproduce a personalized, photographic portrait; and Robert Moskowitz paints two rigid geometric forms on two rectangular canvases to depict two New York City buildings. Thus, both artists employ minimalist-inspired form and process to present specific subject matter. Janet Fish creates work that is simultaneously personal and impersonal, simple and complex, abstract and representational. Although younger than the aforementioned artists, painters Gregory Amenoff, Terry Winters, and Louisa Chase, and sculptor Bryan Hunt insist on representational references while retaining abstract forms and gesture. Their work is rich in organic references and representational allusions with emphasis on paint application, surface texture, and linear description.

By the mid- and late 1970s, artists in New York sought to develop more additive, externalized, and emotional aspects of painting, and explored a maximal rather than minimal saturation of imagery, references, and impact. The sculptural installations of Judy Pfaff and the painted and sewn-fabric paintings of Robert Kushner widen the possibilities in contemporary art, making it more ambitious and offering a wider cross-cultural and multidisciplined approach to its creation. Reliance on figurative motifs also became increasingly evident, infusing painting with greater feeling and reference. In addition to being an autobiographical and psychological source of content, the human form is employed by Eric Fischl, Robert Mapplethorpe, Francesco Clemente, and Sandro Chia to elicit varying levels of sociological, classical, metaphysical, and historical associations.

The youngest generation of artists presented here first became visible in New York in the late 1970s and early 1980s. Their work reflects a diverse visual repertory that includes commercial art and advertising, television and movies, fashion, popular culture, urban graffiti, decorative arts, and ancient cultures. The works of Cindy Sherman and Robert Longo display techniques and compositional devices derived from advertising and cinematic sources.

Sherman casts herself as the subject in photographic fictions and Longo organizes high-impact, commercial images; both manipulate responses conditioned by the mass media. The reliance on images and styles that recall other visual art forms is also apparent in the paintings of Jedd Garet, who presents disjunctive and surreal images in a grand and stylish gesture.

Similarly, David Salle and Julian Schnabel draw upon many sources—art history, mythology, media, memory, and reality—to combine images without regard for continuity of scale or narrative. Salle composes pictures of disparate and appropriated images chosen for both their formal pictorial qualities and ability to suggest yet thwart narrative and symbolic meaning. Schnabel further confounds meaning by creating a visual and textural layering of images, forms, and surfaces that are physically and psychologically emotive. R. M. Fischer, Keith Haring, and Kenny Scharf rely on more popular sources of inspiration. The lamp sculptures of Fischer merge commercially produced and found objects into a work that humorously comments on decorative styles and questions the function of an artwork. Haring's bold, graphic paintings are emblematic of the sociopolitical context of contemporary man, while Scharf's cartoon-inspired characters inhabit an other-

worldly, hysterically surreal landscape. These artists visually reiterate their desire to make an expressive, aggressive, and subjective statement that acknowledges inspiration from other sources but is firmly and actively rooted in the modern world.

The artists presented here continually and collectively question, test, expand, and refine the meanings and definitions of art. They explore varying forms of expression from subjective to objective, personal to public, emotional to logical, abstract to realistic—all consistent artistic issues that characterize major developments in contemporary art. These fifty New York artists illustrate the richness of the city as a cultural capital. They represent a simultaneous layering of three or four chronological and stylistic generations all working at the same time in the same place, contributing to a complex and elaborate weaving of artistic creativity that is presently unparalleled.

50 NEW YORK ARTISTS

GREGORY AMENOFF

It is a source of continuous amazement to me that a painting made many centuries ago can speak with a vibrant and articulate voice today. That this voice lives an almost-tangible life deeply implanted in mere skins of paint further amazes me. I would like to trap in paint a sense of atmosphere, an emotional life—internal and personal—and a sense of growth both akin to nature and foreign to nature. These notions have led me into painting and continue to serve as my primary inspiration.

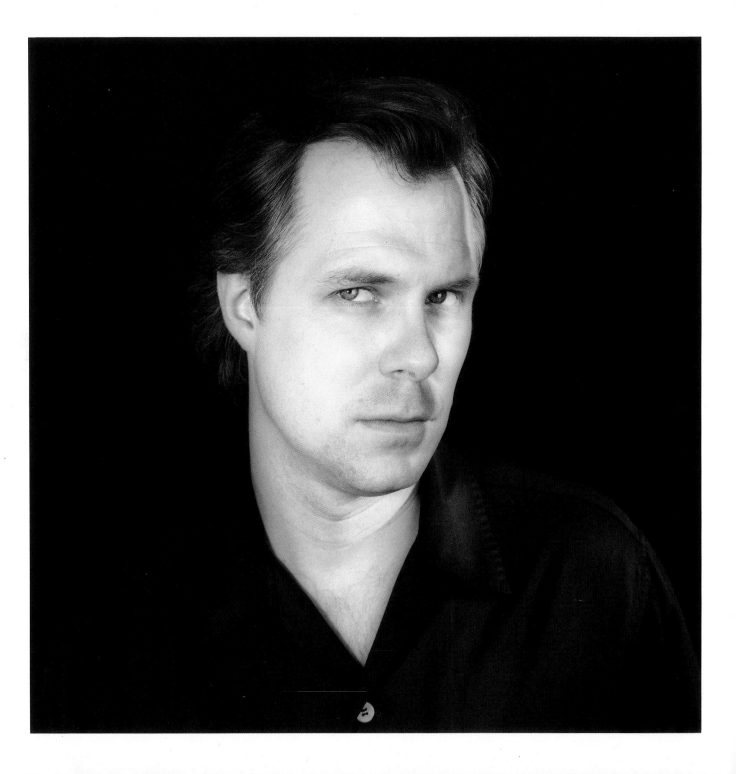

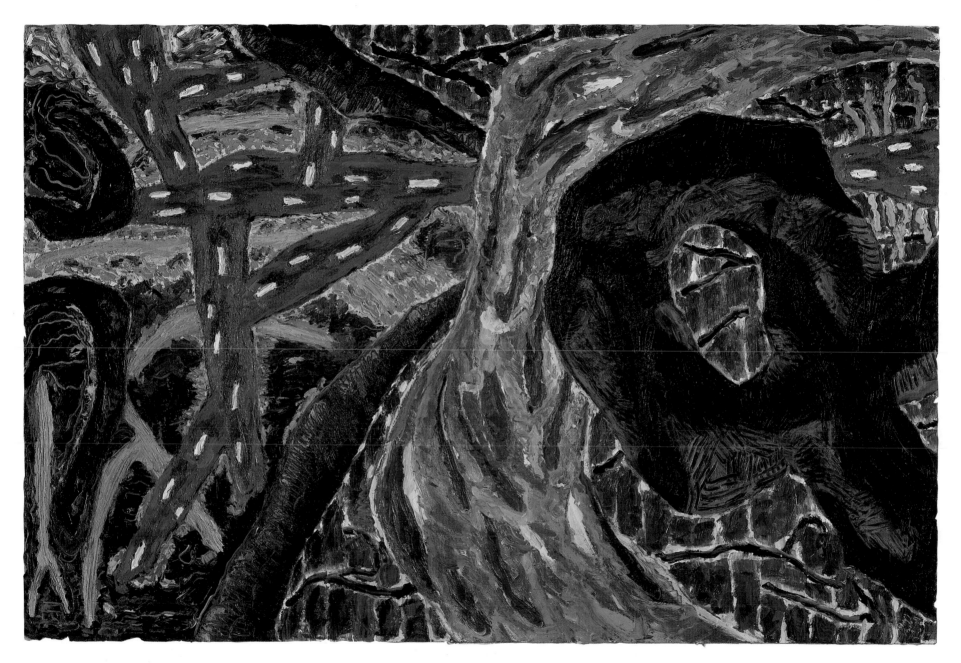

Gordian Knot, 1985
Oil on canvas
105 by 160"
Whitney Museum of American Art, New York; Purchase,
with funds from the Louis and Bessie Adler Foundation, Inc.,
Seymour M. Klein, President

RICHARD ARTSCHWAGER

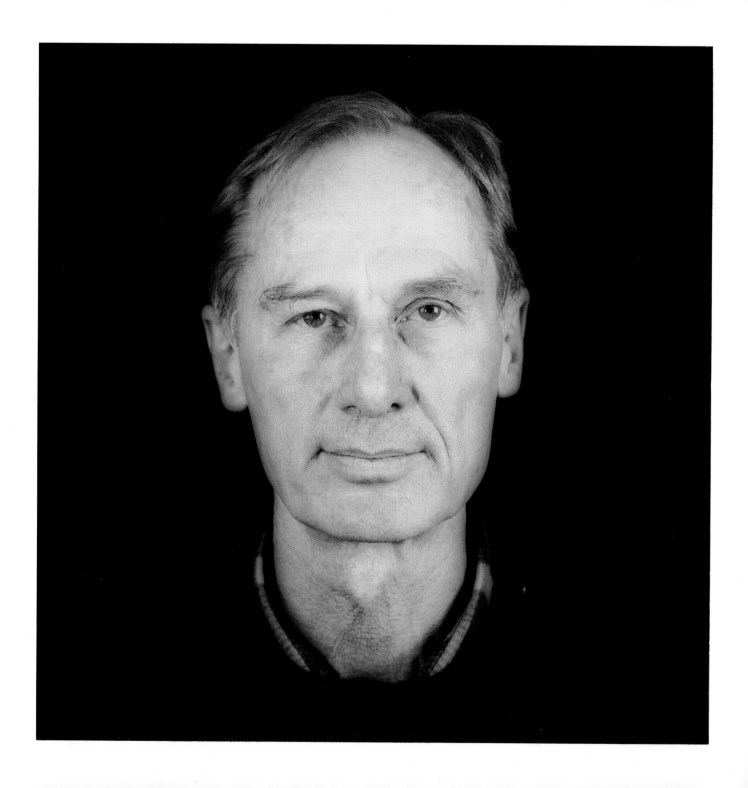

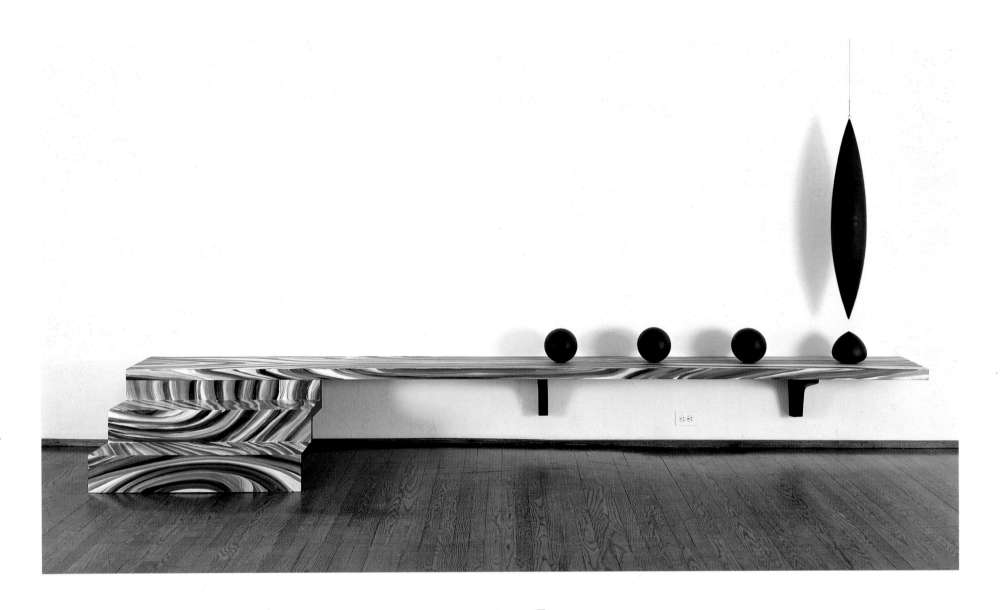

Up and Across, 1984–85
Polychrome on wood
61 by 144 by 35″
Frederick R. Weisman Foundation of Art, Los Angeles

Ever since our mind learned to fly out of our bodies, we have been moving rapidly from the accessible to the inaccessible, and back, rapidly, most likely because the accessible and the inaccessible have been trading places very fast. Maybe the mind is actually staying right where it is. In this sculpt-ed piece I have been busy celebrating passage from the accessible to the inaccessible.

19

JENNIFER BARTLETT

Boy, 1983
Oil on canvas
84 by 180"
The Nelson-Atkins Museum of Art, Kansas City, Missouri;
Gift of the Friends of Art

My approach to certain things is circuitous and indirect. A lot of my work has a kind of withdrawn quality. I mull over things, I ruminate. I exclude things. I am interested in just how I see a place when I'm in it. What's the sensation of being there? What else is in that place? Sometimes the air standing between a tree and me becomes almost palpable. I'm interested in light, temperature, the time of day, wind. In the dictionary, "day" is defined as an interval of light between nights. Night is perpetual, day is a gift.

21

LYNDA BENGLIS

I am interested in work that depends on technology, that is visually exciting, and that hasn't been experienced in art or technology. Through genetic engineering, science is re-creating nature. Artists also do this. Only recently has science been able to understand nature in order to re-create it (e.g., using fusion research to create a star and genetic engineering to create new forms of life). Art ideas that are really inventive do not repeat each other. They re-create the nature of art.

The allusion to and the imitation of nature are the substance of art. I like to think that I mime the spirit of nature in re-creating it. Adjustments to gravity, weightlessness, hardness, softness, and

motion are felt. Painting led me to sculpture; I wanted to free color of its flat form on canvas or board and to free form of much-used flat planes. I work with the probable and stretch it to the possible by using contradictions in material and context. Each work exists in its right scale and motion within the contextual rules I've set up.

Perhaps these rules exist as I make them (that's my illusion), or perhaps they exist as they have always existed and I only allude to them. I am definitely bound by traditional concepts of classicism and beauty, while using technology, and wish to enter the contemporary spirit with this personal game.

Kissel, 1985
Bronze, nickel, chrome on bronze wire mesh
34 by 48 by 12″
Paula Cooper Gallery, New York

LOUISE BOURGEOIS

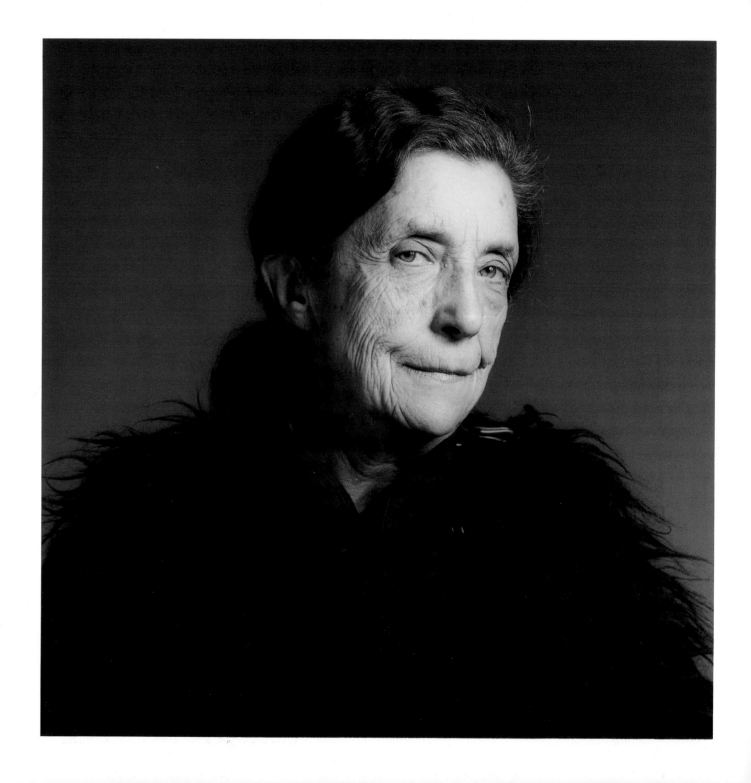

Inspiration is indispensable to my work, but it is hard to come by. It is there or it is not—it is a gift of the gods. The fact is that it is impossible to understand the logic (Cartesian, symbolic, or feminine) of a person in a state of inspiration. It has been equated to regression, but I cannot accept this term. We all know that it is predictable, so it is scientific. I call it a Controlled High.

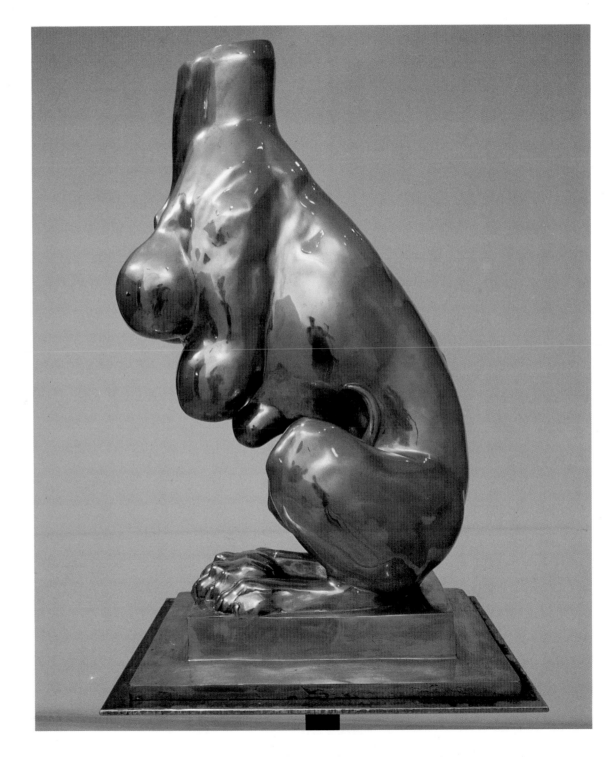

Nature Study, 1984
Bronze
30 by 14½ by 19″
Whitney Museum of American Art, New York; Purchase,
with funds from the Painting and Sculpture Committee

25

LOUISA CHASE

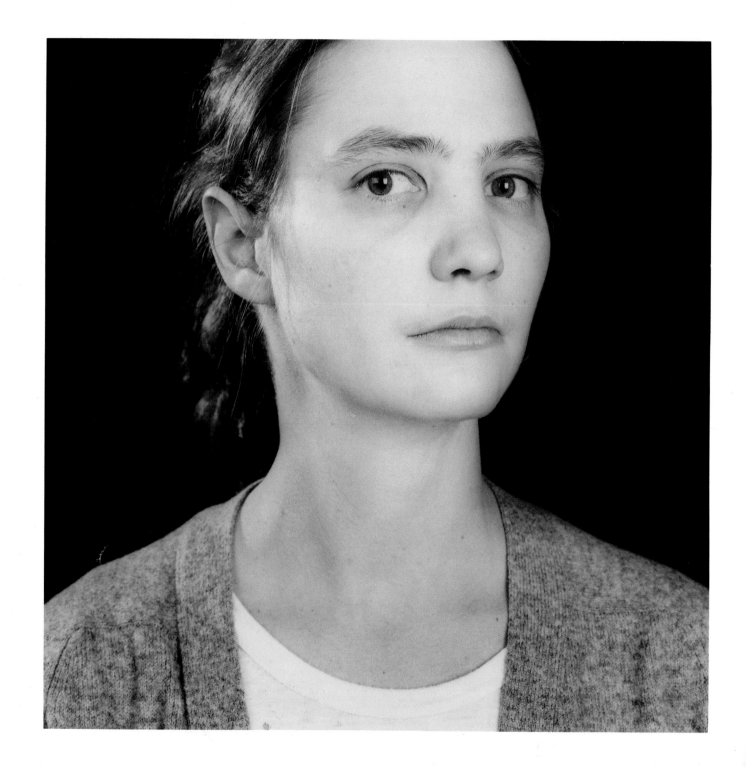

Scribbles—lines adding up—
being something at the same
time as being nothing at all.
Clarity formed by perception.
Plasticity of the gesture—air
coalescing content fused with the
mark, the experience of mark
making—experiential rather than
symbolic. Not what you say but
how you say it—language, con-
frontation—face to face.

Face to Face, 1985
Oil on canvas
96 by 102"
Robert Miller Gallery, New York

SANDRO CHIA

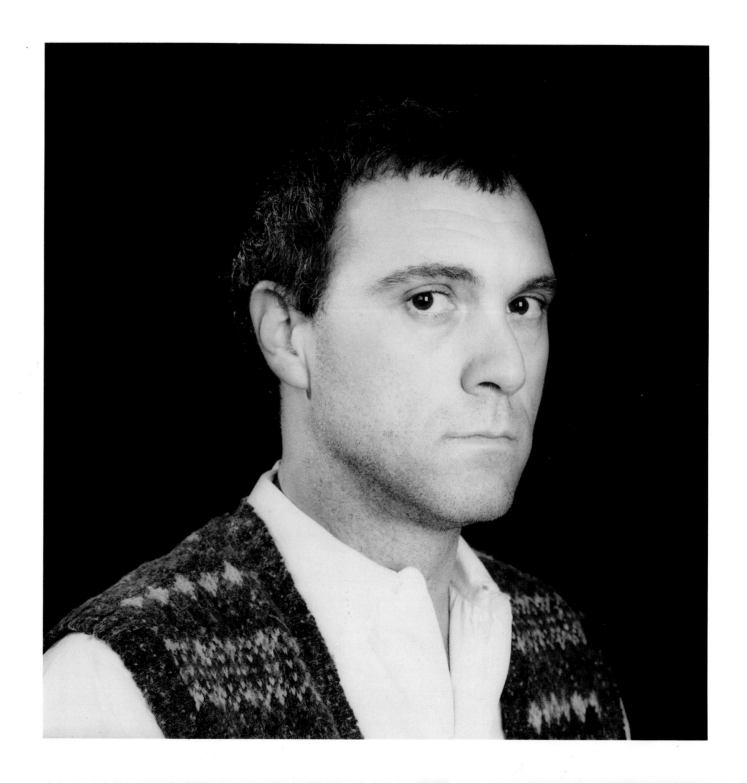

I am a modern artist in the sense that I am here now in the world. I am surrounded by modern iconography and use modern things. But as an artist, I can only be a link in a long chain. The tradition of art is the voices of the dead fathers—all the dead artists. On one hand, the history of art is fascinating and it attracts me. The tradition shows all the possibilities, the chances to approximate truth, the depth of things. So I love painting. But then, this tradition is also telling you that you can't be an artist, that there is no room for you. Today, you not only have to make the work as an expression of the artist's self, but you have to make the necessity of the work, to create a reason for it.

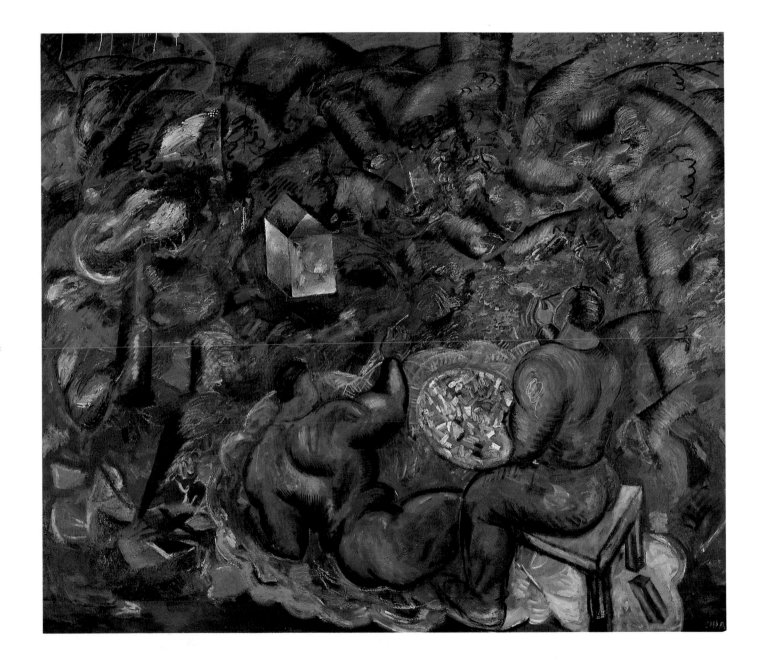

Two Painters at Work, 1982
Oil on canvas
114 by 135"
Private collection

29

FRANCESCO CLEMENTE

What I do . . . is a rational but ritualistic game, comic and sensual, about elements in life. If I could explain more I would be a writer, not a painter. The face, my face, is something I know. I'm interested in the body as a conductor between what we show on the outside and what we feel within. And this is reflected in our eyes, our mouths. The nakedness of the human face has a great attraction for me. It is the one part of the body that we do not cover. I look at myself and see that my face is always changing. So, in fact, the image is not always the same.

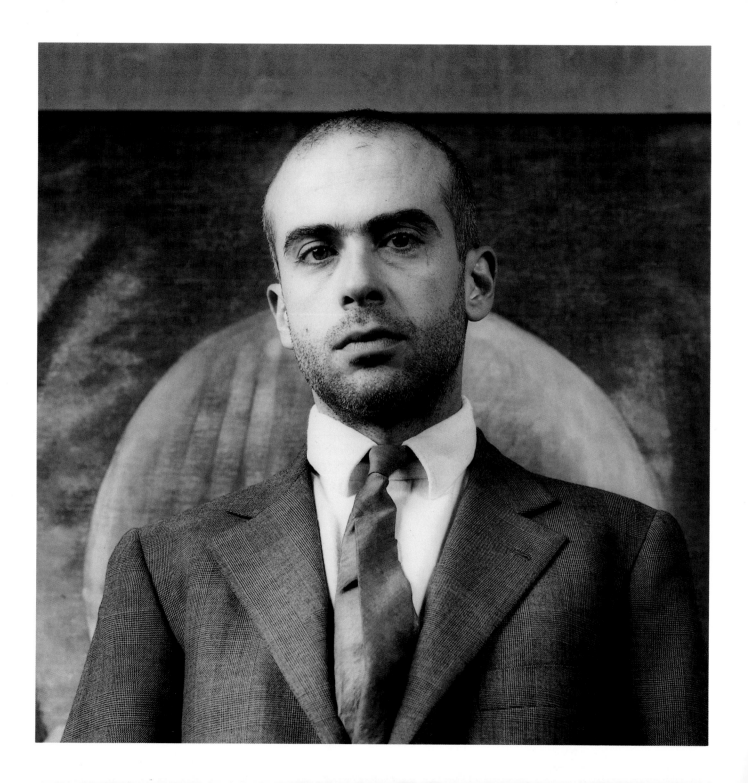

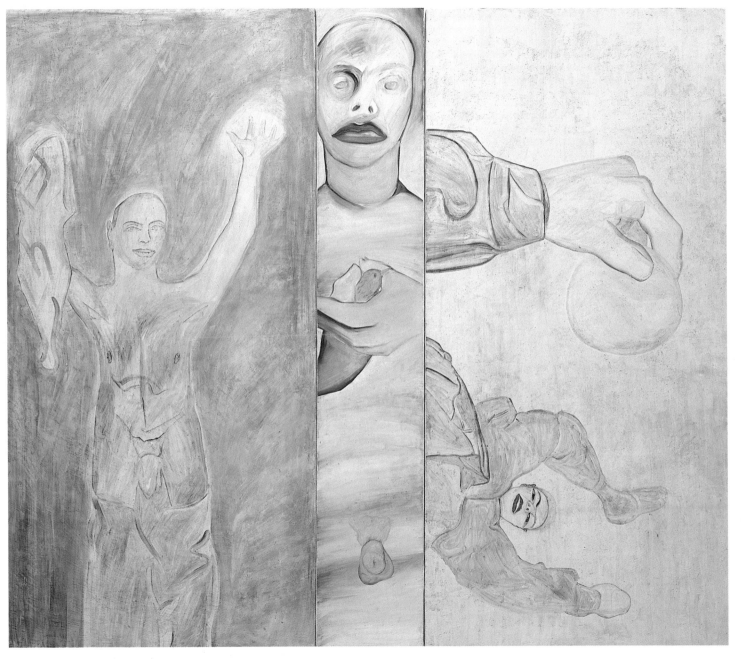

Conversion to Her, 1983
Fresco
96 by 112½ "
The Museum of Modern Art, New York; Purchase, with
funds from the Sid R. Bass Fund

31

CHUCK CLOSE

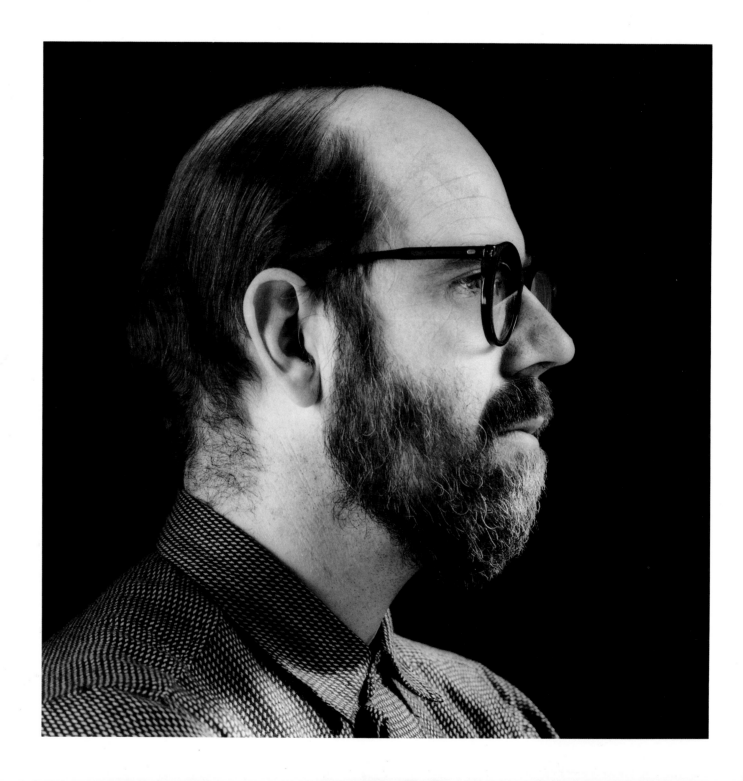

The fingerprint is a very personal mark. My work in general seems more personal and my involvement in it more physical; however, the way I'm working remains similar in the way the paintings are constructed or "built." I still work incrementally. The increments are now simply fingerprints. There are still limitations—the size of my thumb and my forefinger, and the various ways I can manipulate them to make the marks. I enjoy building an image to which people can relate through a life experience, which might in fact move them, and still be made up of rather stupid, little "building blocks."

I've chosen recently to paint the people who matter the most

to me. I've always painted my friends, but only those friends whose image appealed to me in a certain way. Someone who looked like a "Chuck Close." *Fanny* is my wife's grandmother, my children's great-grandmother, and the only surviving member of a very large family that was murdered by Hitler. Her face is a record—almost a road map—of her experiences.

I have never allowed myself to paint old people or babies, because the images seemed too sentimental and a little too much like pages from *The Family of Man*. When I was a student, *The Family of Man* show at the Museum of Modern Art was an incredibly important exhibition. At that time all I was interested in was abstraction, paint, drips, and splatters. But something about those images bothered me, stayed with me. Since I began to work from photographs, I realized the power of photographic images scared me. I've always had a kind of love-hate relationship with photographs. I felt the need to keep a certain distance. At the same time my paintings always transcended the photograph, even at the beginning. The paintings looked more like the people than the photographs did. No matter what degree of likeness existed in the photograph, I always ended up putting more into the painting. The painting of Fanny has a lot of me in it.

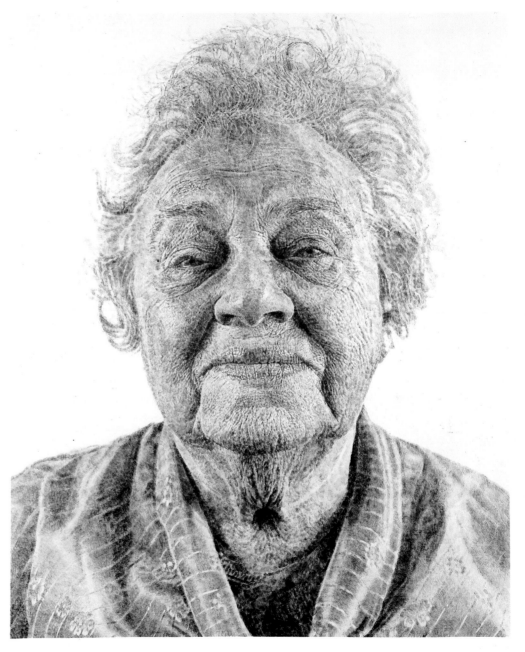

Fanny/Fingerpainting, 1985
Oil on canvas
102 by 84"
The Pace Gallery, New York

33

WILLEM DE KOONING

I f you write down a sentence and you don't like it, but that's what you wanted to say, you say it again in another way. Once you start doing it and you find how difficult it is, you get interested. You have it, then you lose it again, and then you get it again. You have to change to stay the same.

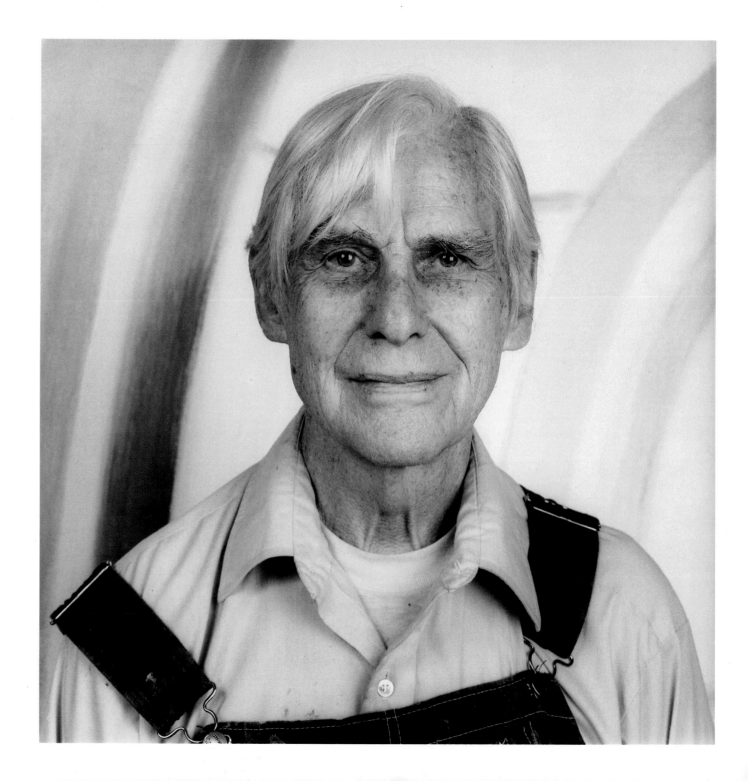

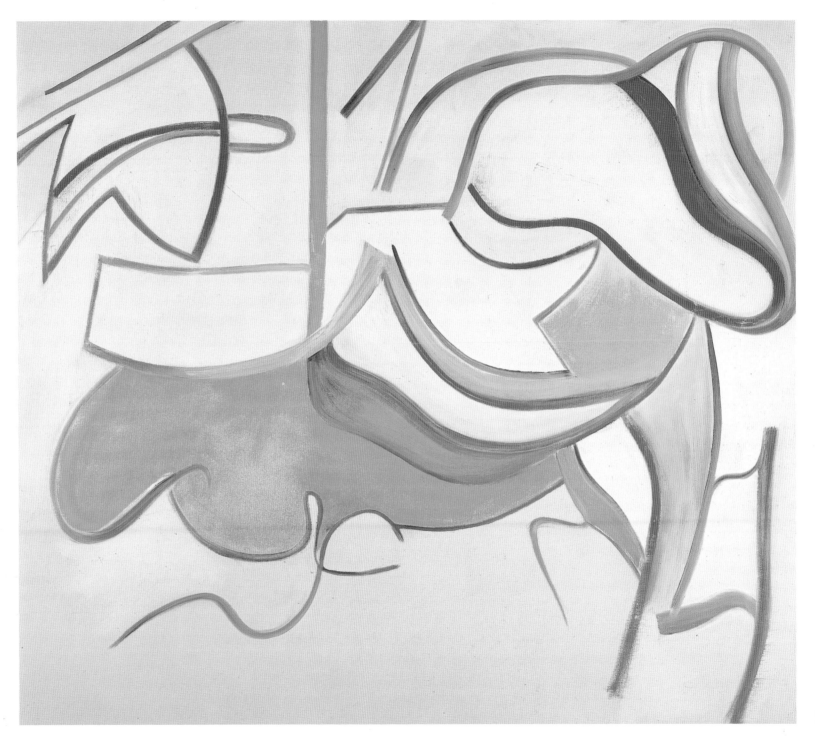

Untitled IX, 1985
Oil on canvas
77 by 88"
Private collection

MARK DI SUVERO

The resonance of forms in our daily life—from DNA to sky-scrapers, suspension bridges to galactic spirals—affects every part of our life, and when those resonances become objectified in sculpture they can electrify our life. Spatial sculpture requires a different set of poetics than monolithic sculpture: the stereoscopic vision (the difference between keeping the left eye open and closing the right one and vice versa) gives depth of field and suggests the surrounding space that full, life-size, walk-through spatial sculpture achieves. To be surrounded by sculptural form can be exhilarating and an echo of all humanity's womb-memory. The history of spatial sculpture (Rodin's *Burghers of Calais* and Giacometti's *Palace at Four A.M.)* is a part of humanity's urge to explore the moon and the planets (space exploration), and when motion and participation are added to

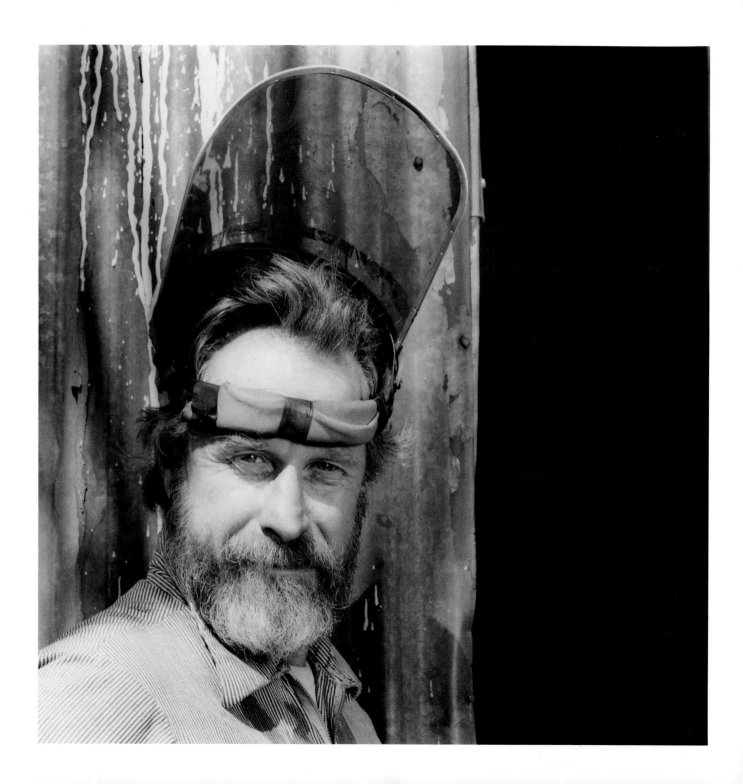

spatial sculpture, then we reach the electrifying experience that great music or great poetry can give.

Richard Bellamy, my long-time friend and art dealer, arranged for *Huru* to be at the Storm King Art Center in upstate New York. *Huru* has an eight-ton, rotating upper part that moves on a one-hundred-ton bearing and a knife-edge balance in a saddle. The piece was entirely done from flat plate and straight beams, which, like white paper to ink and carbon, offer an infinity of imagistic possibilities limited only by the imagination. To unleash the imagination so that the sculpture semaphores its motion from the roots of life requires the recognition of poetic form, the capacity to give that form to materials in the knowledge of how to clue and define space.

I built *Huru* in Petaluma with the assistance of Lowell McKegney, whose grandmother taught me at the age of eight how to work wood. I was a crane operator (after eighteen years of running a crane, I am finally a member of the Operating Engineers Union, Local No. 3) and I did most of the welding and oxy-propane cutting. I draw directly on the steel, then cut,

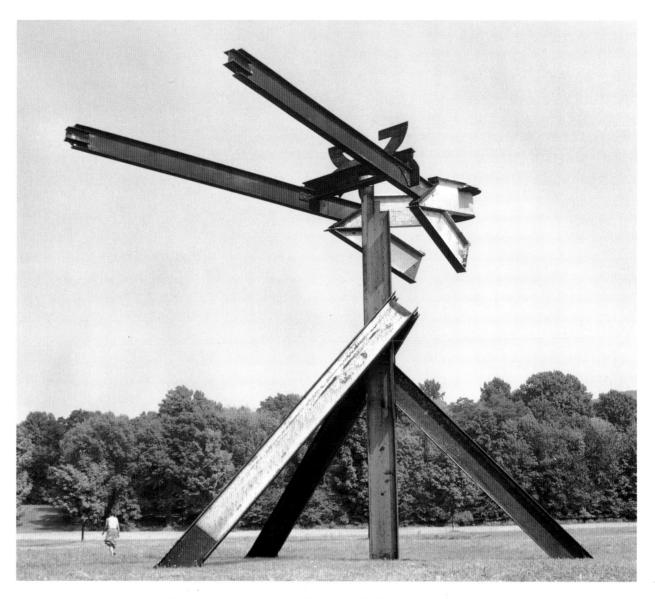

bend, form, and weld the planes or beams. Lowell and I do the rigging together. To achieve poetry in a piece of sculpture, one must know how to dream, how to draw the dreams, and how to see the interwebbed, interdependent dance of this beautifully colored energy field that we too bluntly call "life" or "world." *Huru* is an aboriginal Australian word: I named the piece because it seemed to have an aboriginal quality.

Huru, 1984–85
Steel
32 by 50 by 50'
Oil & Steel Gallery, Long Island City, New York, and the artist

37

RICHARD ESTES

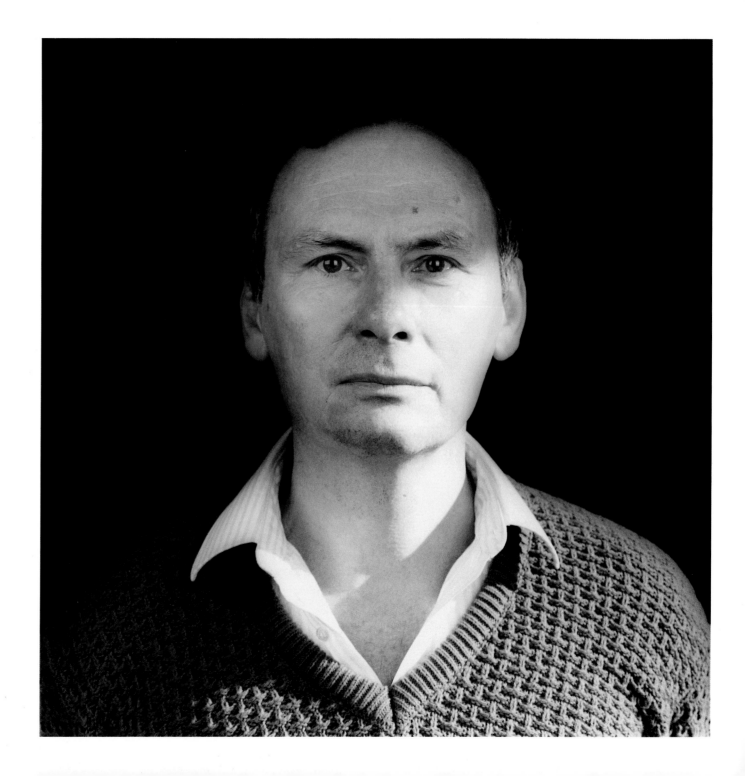

I have heard it said that when painters get together, what they really talk about is what brand of turpentine they use. What this suggests is that the ideas and the feelings can be assumed and come without effort. The problem, though, is using oils or some other sticky substance mixed with different-colored powders to nail them down on a flat rectangular surface.

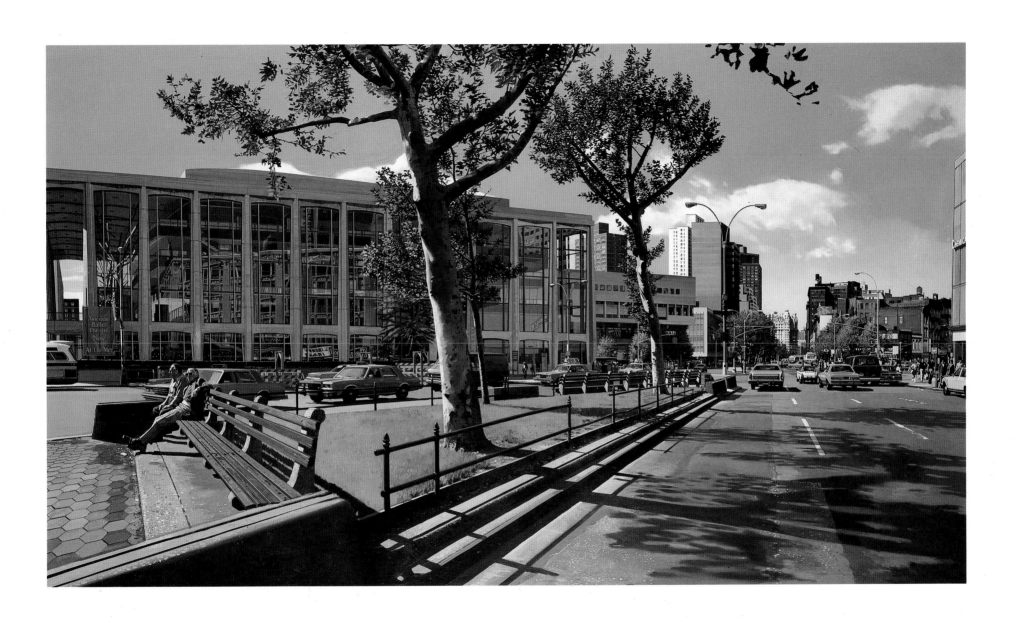

Broadway and 64th, 1984
Oil on canvas
40 by 72"
Collection of Martin Z. Margulies

39

R. M. FISCHER

The lamps fluctuate between being elegant and serious, whimsical and crazy, but do not emphasize one more than the other. They deal with both simultaneously. I am interested in objects that exist in the real world and that have quasi-functional purposes. I want to combine those two things. I've tried to make objects that relate to assemblage or sculpture and also incorporate the notion of the functional object as a semiotic experience. I want the work to reach out into as many different contexts as possible. I'm trying to evoke a sense of the future—that the objects could exist in the future—while also evoking the past. The sculptures are made of artifacts. I don't want them relegated to a specific historical time.

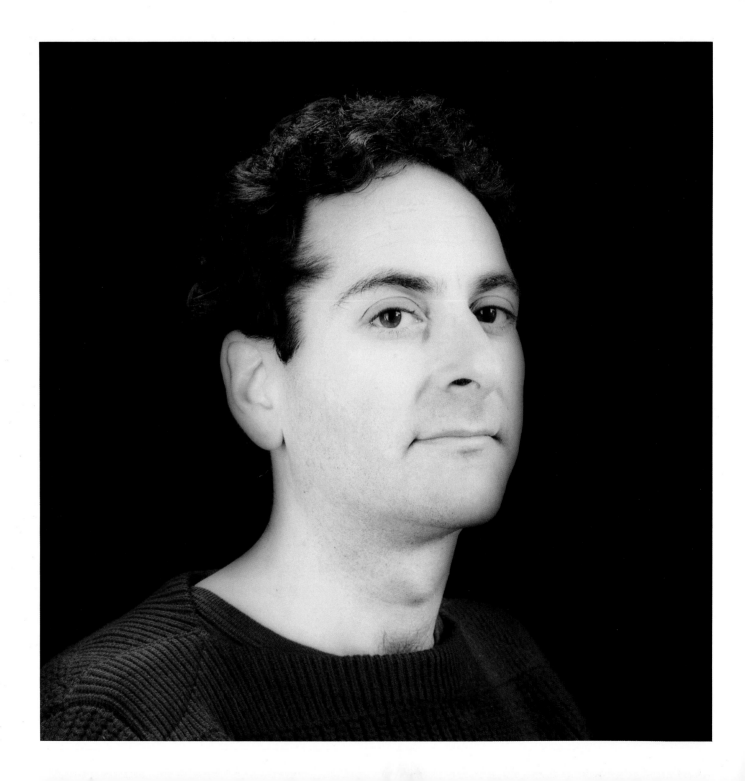

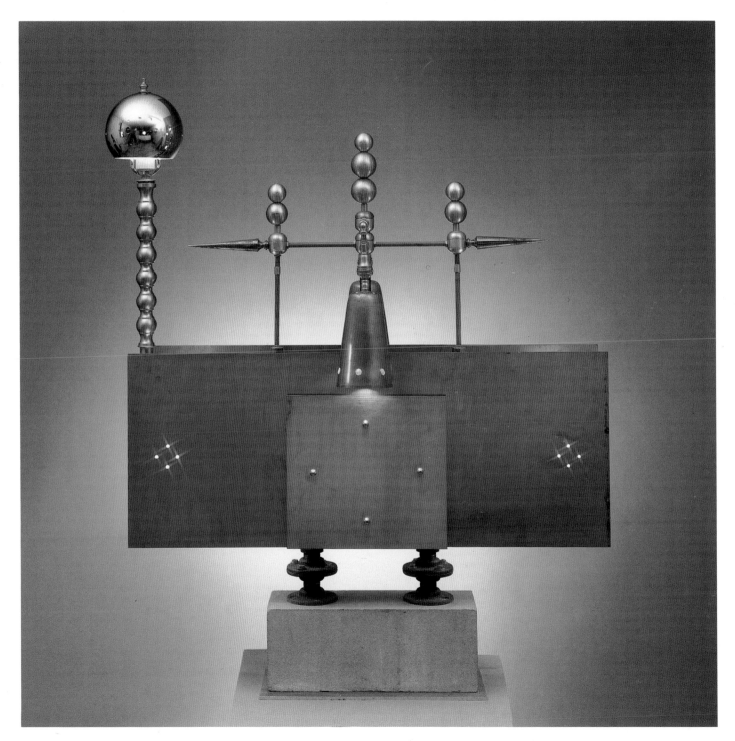

Dynasty, 1983–84
Brass, steel, aluminum, plastic, limestone, electric lights
44 by 36 by 16"
Collection of First Bank of Minneapolis

41

ERIC FISCHL

F or me, painting is the process
whereby I return my thoughts
to feelings.

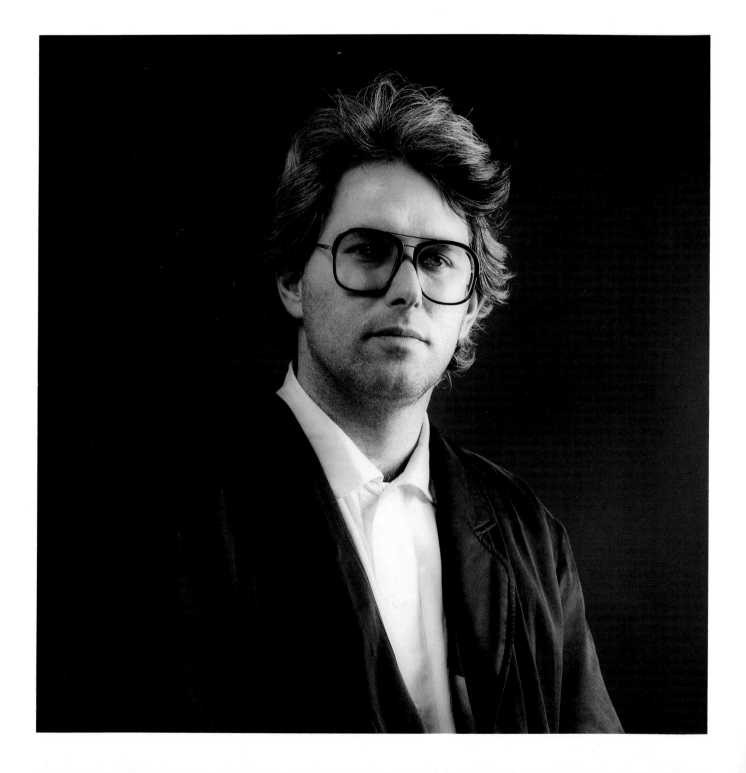

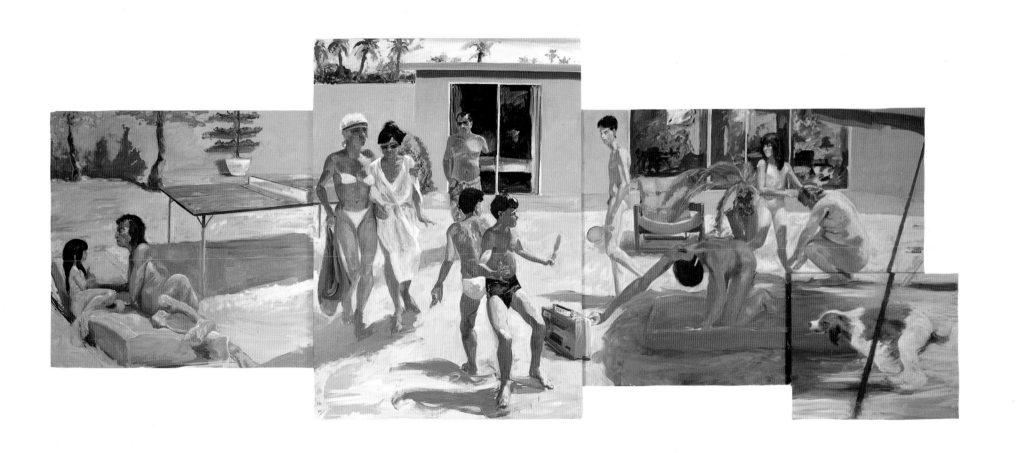

Saigon, Minnesota, 1985
Oil on canvas
120 by 297"
Collection of Robert and Jane Meyerhoff

43

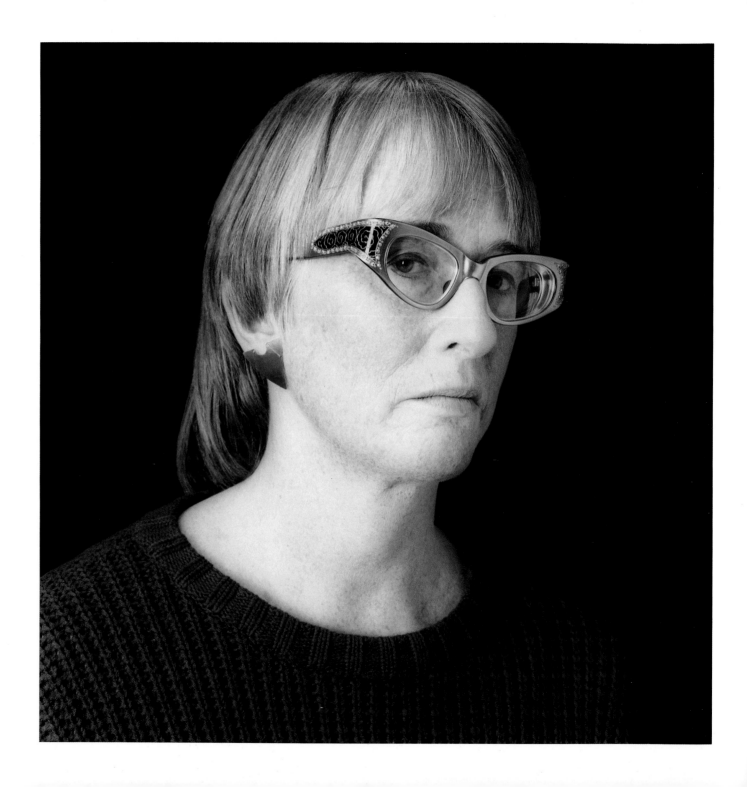

JANET FISH

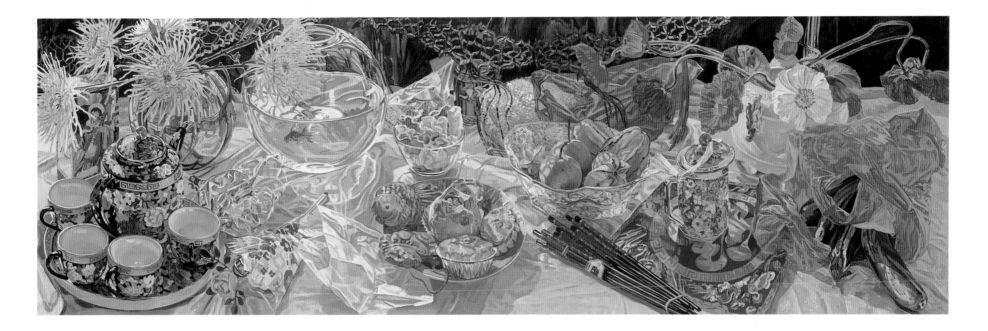

The painting is a contained world, the structure coming from the movement of color over the surface. I like the idea of gesture and energy organizing the canvas; the gesture formed not simply by the quality of the brushmarks but by the push and flow of colors from one form to another. My primary subject is the governing character of the light. There may be a hint of narrative and any image has a multitude of associations, but the real message is read in the color, the movement, and the light. When selecting objects and building a painting it is not luminosity per se that I'm looking for, but a subject that provides an opportunity for overall activity. Light is not the only source of this activity. I am not interested in the objects as discrete presences but in the analysis of the dynamics of the visual relationships. Appearances are always changing, I change. It is not possible to "copy" a reality that is in flux. I take from that reality; I choose to see what I will, and that choice comes from an attitude toward painting and an attitude toward the things I am painting.

Chinoiserie, 1984
Oil on canvas
42 by 132"
Collection of PaineWebber Group, Inc., New York

45

JEDD GARET

In the late 1970s, I said I wasn't a painter because I still considered myself a conceptual artist who was using paint the same way a conceptual artist used photographs or film. I still hold to that statement. I want the image and I want the fastest and easiest way to get it there. Obviously, I want it to look right, but I'm completely unconcerned with finesse, and I think that has its roots in a conceptual way of thinking. Style is very important and is a key element of my work—historical style, current style, mixing styles. It is a little difficult to talk about the content of my work, because basically there isn't any. The content is the style. The word content always threw me off, because a painting is a painting; it's there for you to look at. Basically, it's a style, and, whatever the content is, has to do with what the style is.

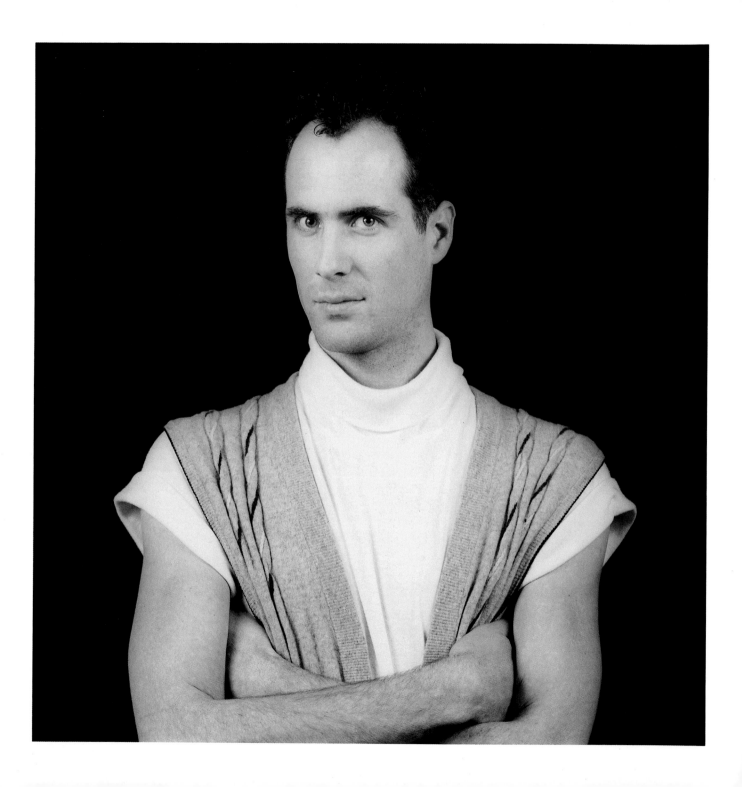

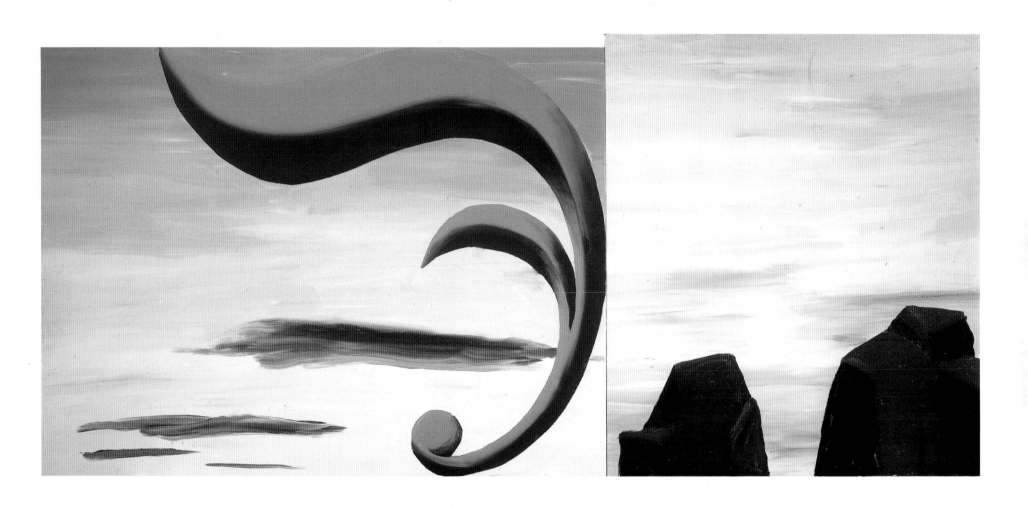

Big Atmosphere, 1983
Acrylic on canvas
72 by 158"
Robert Miller Gallery, New York

47

LEON GOLUB

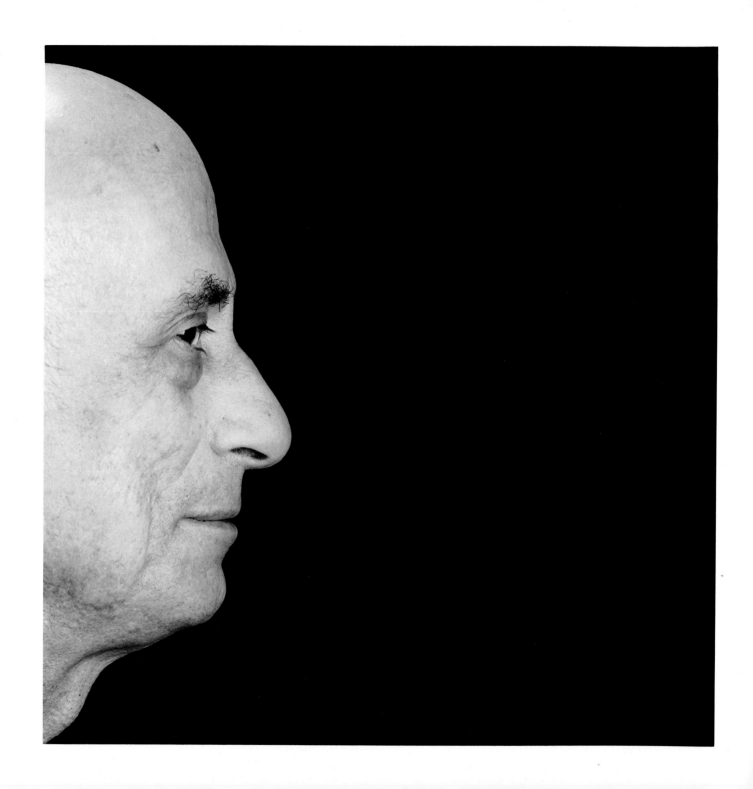

Film is a time art—protagonists arrive on scene, take action, and finally whole personal and/or social histories have been enacted before our eyes. Compared to this, the visual arts are for the most part supremely static. One of the reasons painting and sculpture have often been decried as regressive or in a past time warp is their static positioning. The damn things are inert and are anything but a reflection of the heralded speed and mobility of the twentieth century.

Of course we recognize that "inert" objects can have all kinds of pleasurable or meditative aspects to them. And, in fact, much of painting and sculpture in the twentieth century has (if not initially in intention) somehow become associated with notions of comfort and ease. They offer pleasant sensations of the sensory attributes of the world we inhabit.

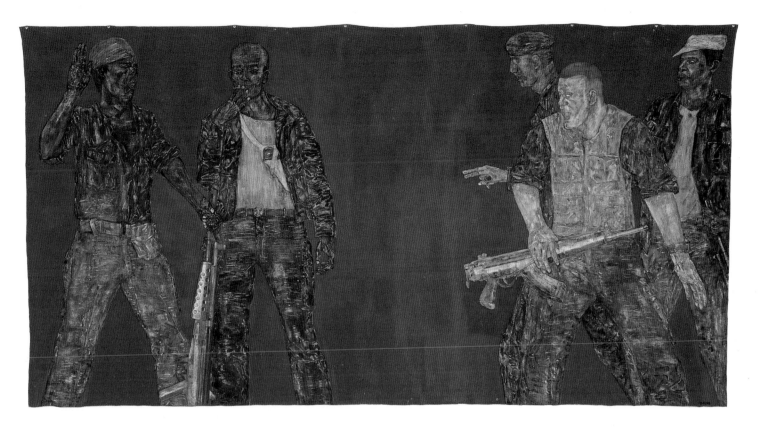

I prefer to project painting in its stasis as potentially uncomfortable, if not, in fact, unendurable. Since the object won't go away, we may have no recourse but to escape, walk away. This has a lot to do with our immersion in a world that is being continuously totalized and atomized simultaneously. It's a world of "no exit" from the continuous saturation of spectacle and image—much of which can be horrendous in impact and detail. Through media we are under constant, invasive bombardment of images—from all over—and we often have to take evasive action to avoid discomforting recognitions.

Due to the static, nonfleeting aspect of art, one often encounters objections to either political or violent subject matters by individuals who can accommodate themselves relatively easily to such content in film or novels. The visual arts have often occupied a domesticated comfort zone and there are many in the art world who would just as soon leave it that way.

In saying all this I realize that I am apparently setting myself up as a special example with a theory such as that of the "unendurable," which can be of course at the same time quite endurable and relatively easily assimilated or even sanitized into general cultural practice. Nonetheless, the work should have an edge, veering between what is visually and cognitively acceptable and what might stretch these limits as we encounter or try to visualize the real products of the uses of power.

Mercenaries IV, 1980
Oil on canvas
120 by 230"
The Saatchi Collection, London

NANCY GRAVES

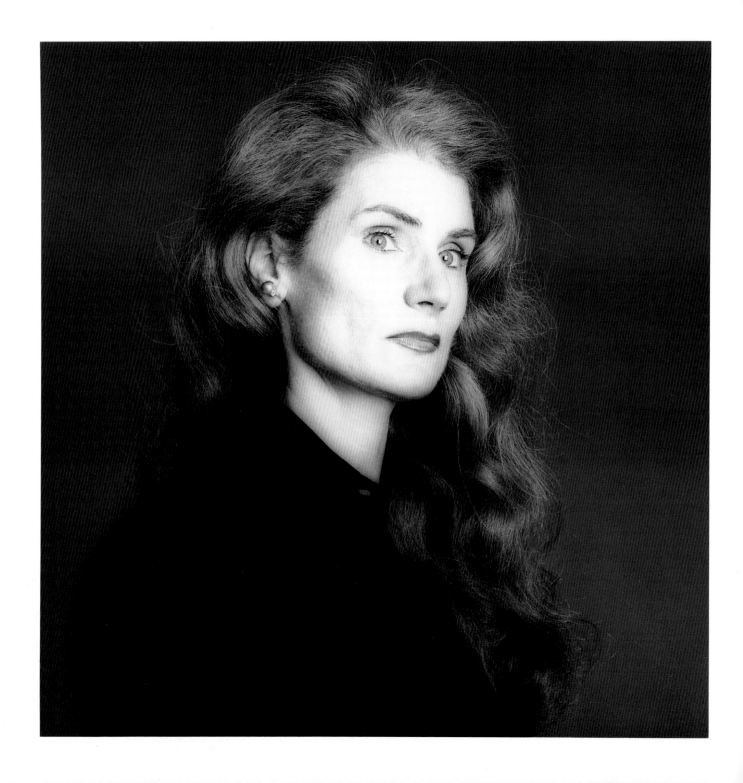

Without the aid of drawings, I conceive a sculpture by selecting from an inventory of hundreds of directly cast, organic forms. These are laid out on the floor and relationships are varied until the unexpected occurs. As parts are welded together, changes in structure, balance, and three-dimensional relationships come into play. What originally appeared to be a vertical element could become a base. Whereas the casting may take months, the assembly takes a few hours. Historical expectations for this most traditional sculpture material are subverted by working against logic—what the eye would expect—and by assembling without premeditation the directly cast objects.

Zag, 1983
Bronze with polychrome patina
80 by 37 by 27¼"
Private collection

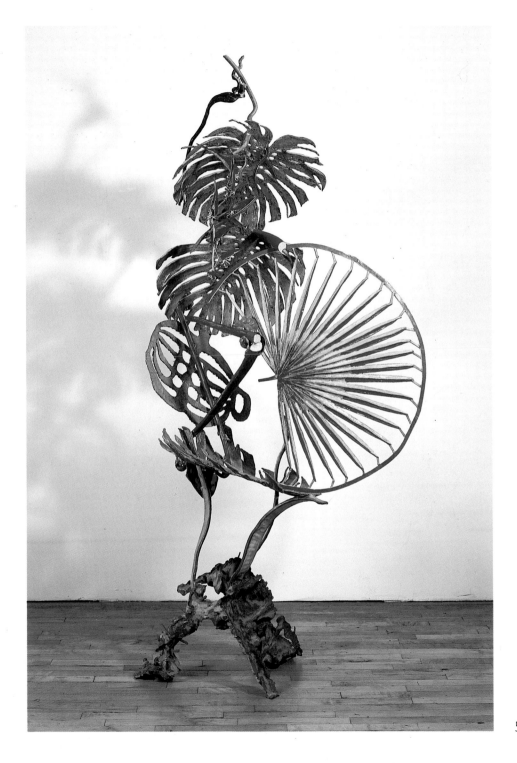

RED GROOMS

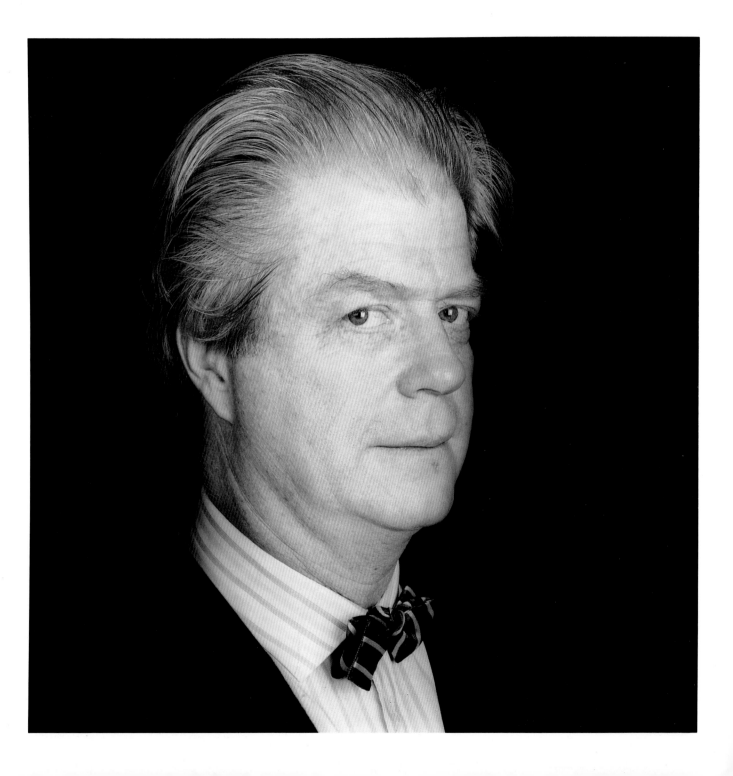

I f "To err is human," then I would like to dub my art excessive "err art." Excessive comes to mind for several reasons; my first cultural experiences were Hollywood films. My criterion for choosing which film I wanted to see was to look at the photo display outside the theater and pick the movie with the most excessive number of extras. Then there was the time of my debut in the late 1950s when I perceived excellence in paintings to be determined by the amount of excessive emotion on display.

Since then I have been trying excessively to use the means available to me to depict a somewhat operatic view of our times and foibles.

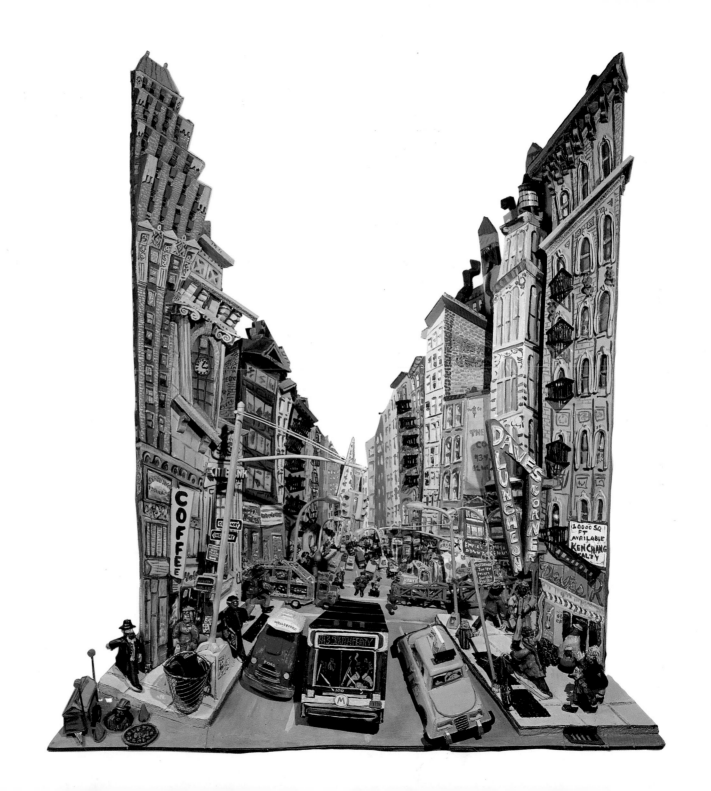

Looking Along Broadway Towards Grace Church, 1981
Painted wood, board, wax, foam-core
71 by 63¾ by 28¾"
Marlborough Gallery, Inc., New York

KEITH HARING

The act of creation is a kind of ritual. The origins of art and human existence lie hidden in this mystery of creation. Human creativity reaffirms and mystifies the power of "life." "Life" is the subject and the object of everything I make. When the act of creation is really successful, the "thing" creates itself. The artist is only a vehicle, a tool. Once created, the "thing" has a life of its own. I want to live and make things that live.

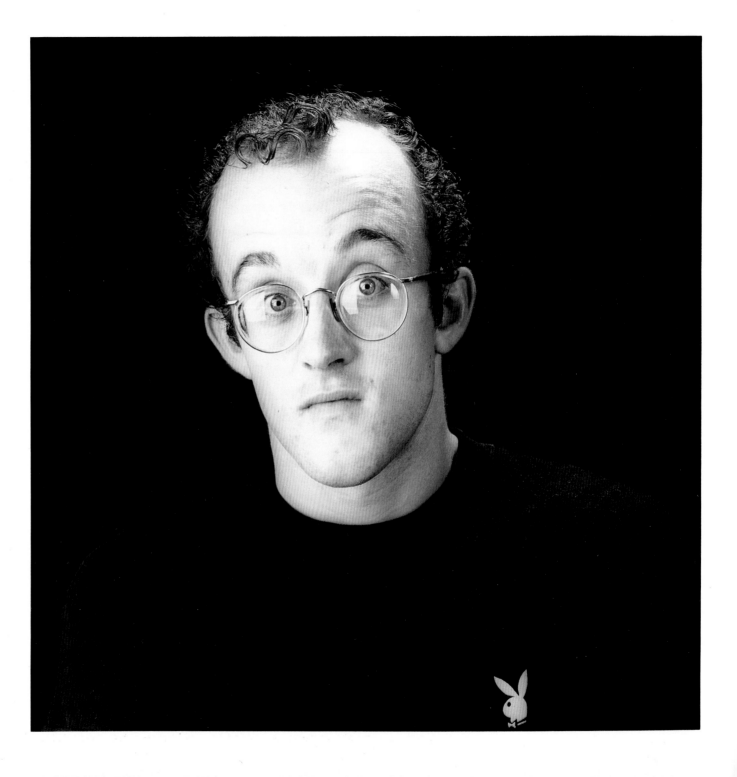

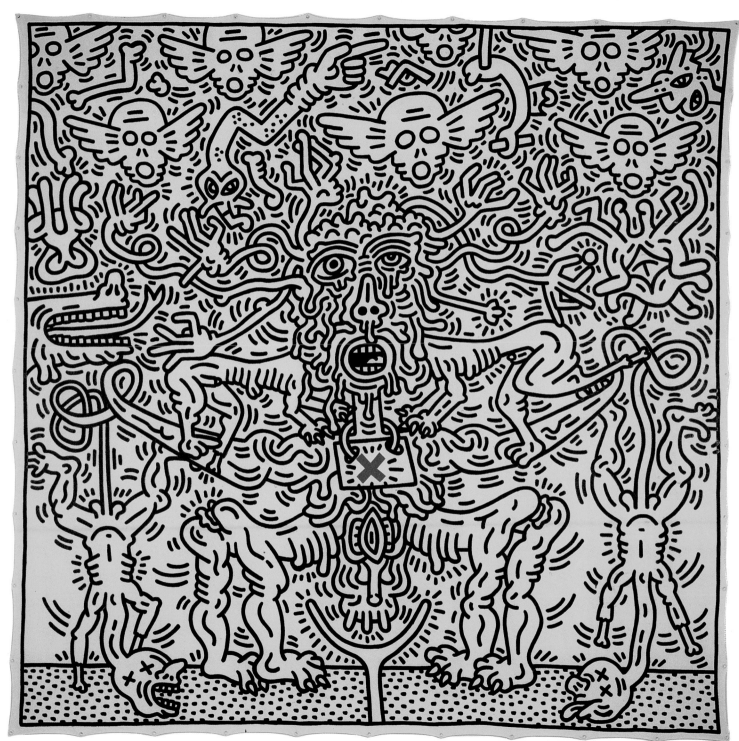

Untitled, 1985
Acrylic and oil on canvas
120 by 120″
Collection of Dr. Peter Ludwig

55

BRYAN HUNT

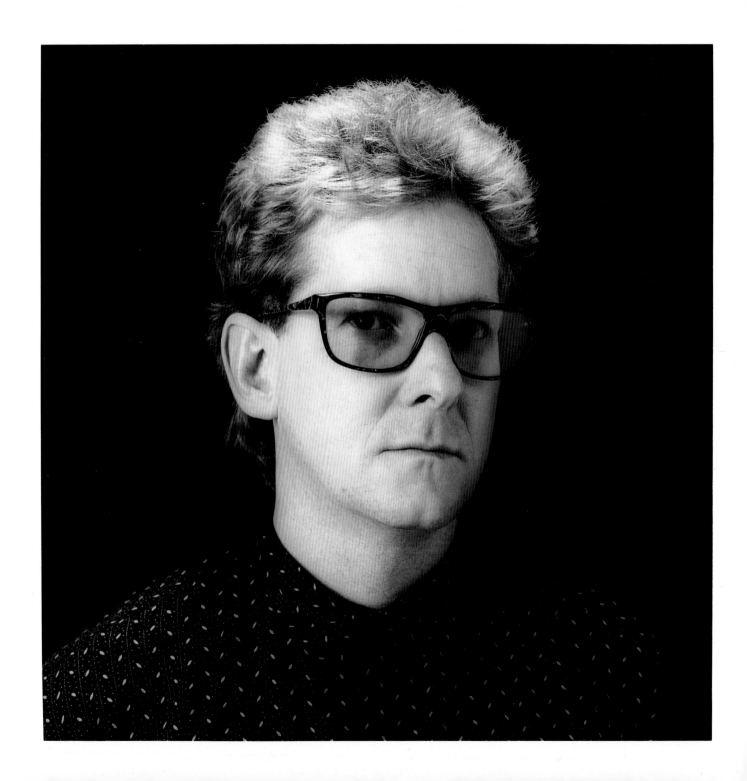

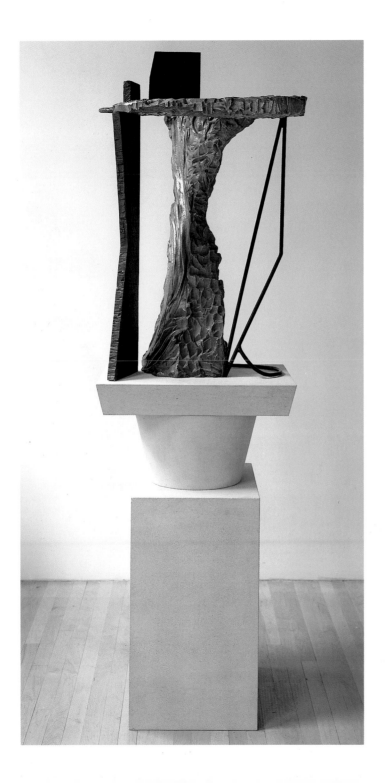

To bring a line out from the mass or a shape means to establish an interplay with three-dimensionality. The line has a relationship to either space—opening it up—or the form reflecting the shape it delineates. It is a strong visual experience to see the line acting in this way.

Dancers, 1985
Bronze on limestone base
92¼ by 27⅝ by 25"
Blum Helman Gallery, New York

57

JASPER JOHNS

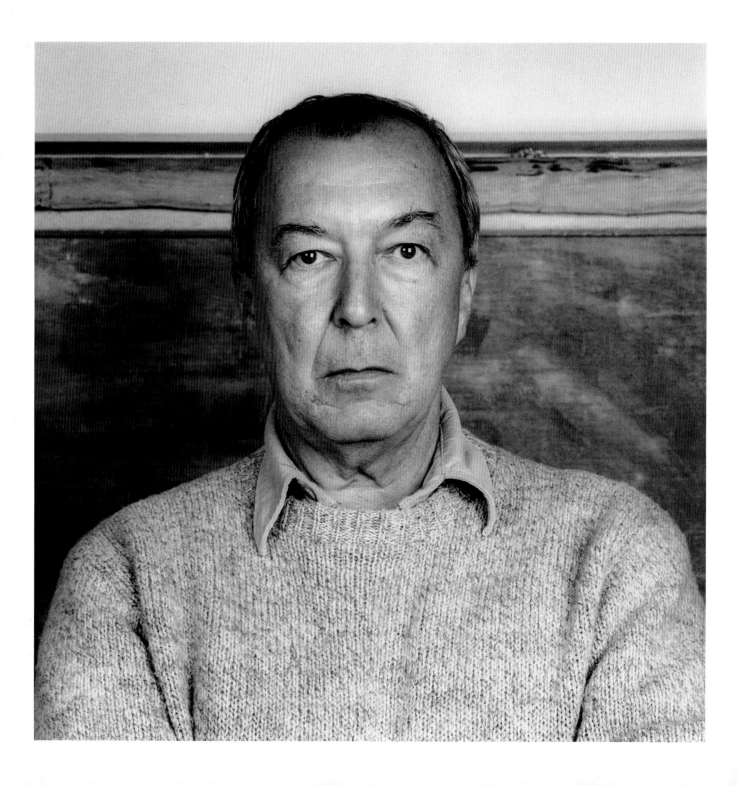

In my early work I tried to hide my personality, my psychological state, my emotions. This was partly to do with my feelings about myself and partly to do with my feelings about painting at the time. I sort of stuck to my guns for a while, but eventually it seemed like a losing battle. Finally, one must simply drop the reserve. I think some of the changes in my work relate to that. I think when you're young you set a lot of limits because you have the need to be very clear to yourself. Once, if I did something in my work that reminded me of someone else's work—an idea, a gesture, paint quality—I would try to get rid of it. But now it wouldn't faze me in the least.

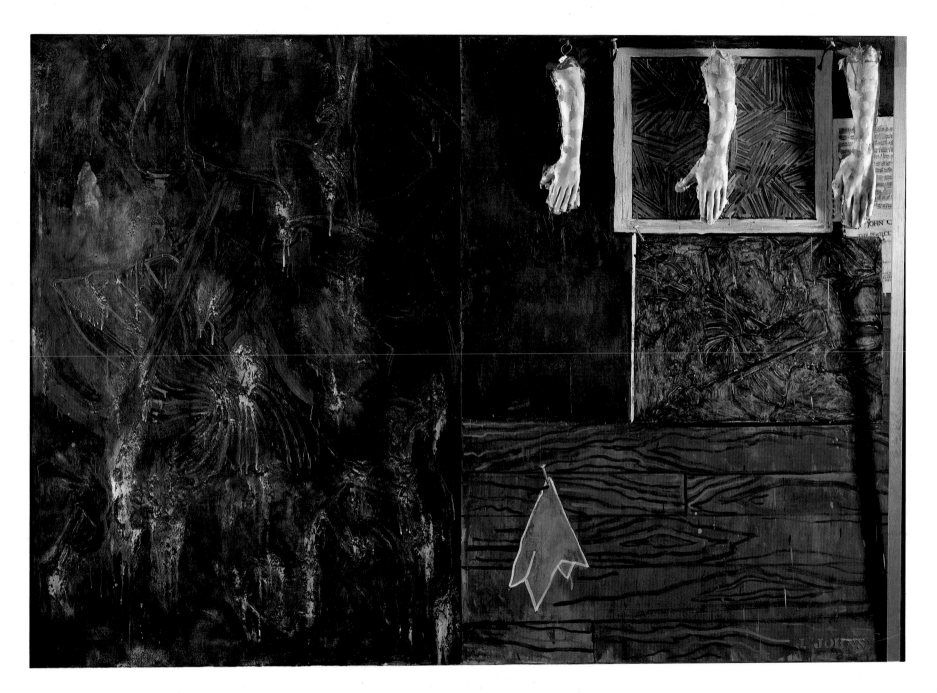

Perilous Night, 1982
Encaustic on canvas with objects
67 by 96"
Collection of Robert and Jane Meyerhoff

DONALD JUDD

The installation and context for the art being done now is poor and unsuitable. The correction is a permanent installation of a good portion of the work of each of the best artists. After the work itself, my effort for some eighteen years, beginning in a loft on Nineteenth Street in New York, has been to install permanently as much work as possible, as well as to install some by other artists. The main reason for this is to be able to live with the work and think about it, and also to see the work placed as it should be. The installations provide a considered, unhurried measure by which to judge hurried installations of my own and others in unfamiliar and often-unsuitable places. This effort seems obvious to me but few artists do it, though there is a tendency to keep earlier work; the idea of a permanent installation for visual art is nearly unknown to the public.

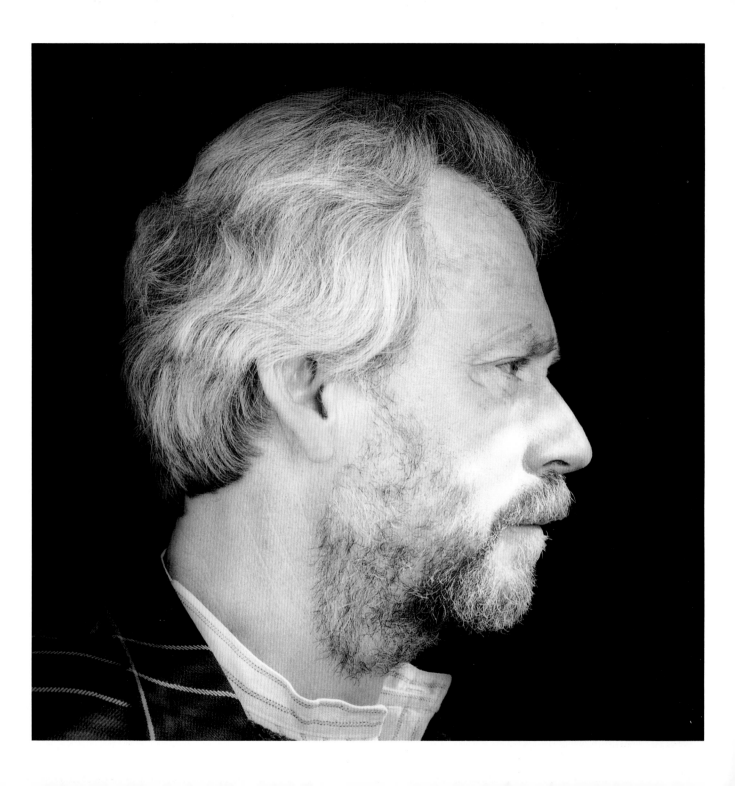

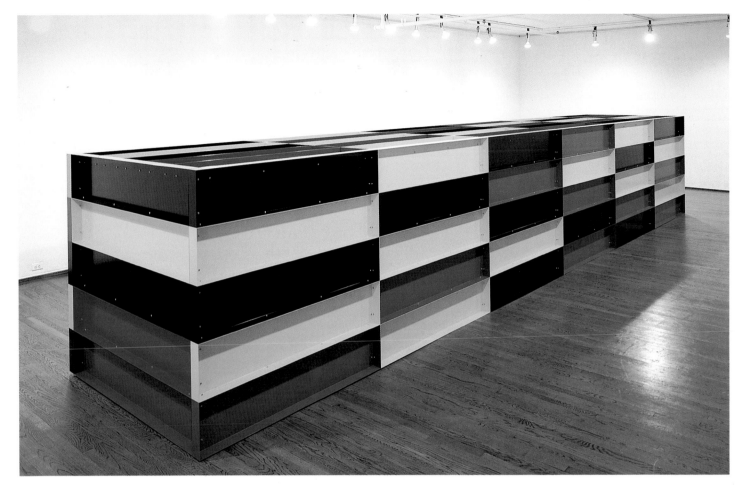

A museum of contemporary art, sometimes joined to a historical museum (itself debatable), has become a necessary symbol of the city and the culture of the city all over the world. One result of the thoughtlessness of this expensive efflorescence is that no museum is able to exhibit physically the art of the last twenty years, much less the last forty, let alone that of the last one hundred. Such an institution is no proof of culture.

The best artists living now are valuable and not replaceable; society should see that their work *gets* done while they're alive, and that the work is protected now and later. If this society won't do this, at least it could revise some of its attitudes, laws, and tax policies to make it easier for the artists to do so. Art has no legal autonomy.

Permanent installations and careful maintenance are crucial to the autonomy and integrity of art—especially now when so many people want to use it for something else. Permanent installations are also important for the development of larger and more complex work. It's not so far from the time of easel painting, still the time of the museum, and the development of the new work is only in the middle of its beginning.

Untitled, 1984
Painted aluminum
150 by 900 by 150 cm.
Collection of the artist

61

ALEX KATZ

The distance between my intentions and the viewer's reception is one of the mysteries of painting. I try to make the image as unavoidable as possible while having multiple references. This, coupled with the fact that I am partially blind to the content of my personality and to its references, produces an object that has more varied responses than I could anticipate. There are viewers who confirm what I know and what I intend. They tell me that I am sane. There are some viewers whose responses make what I do clearer to me. They enlarge my appetite.

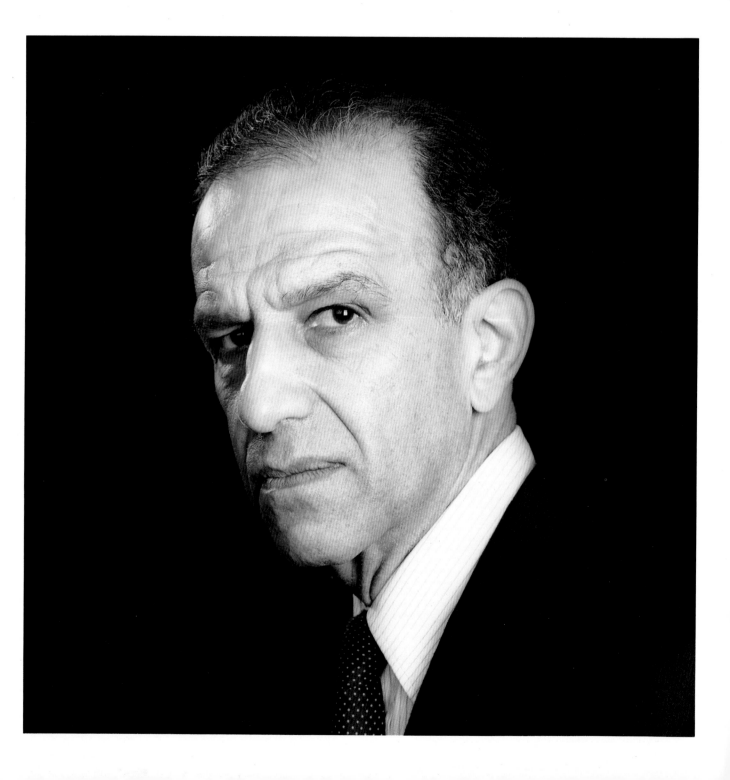

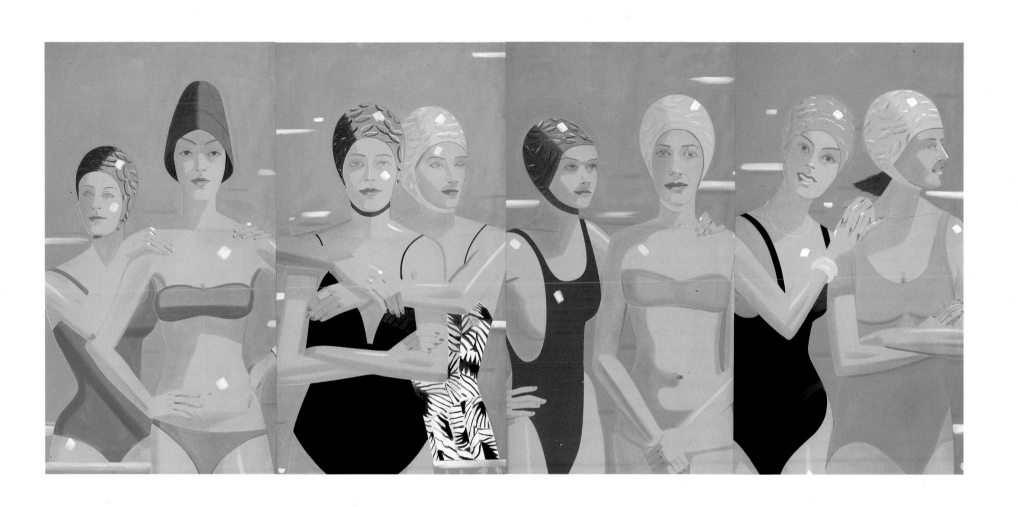

Eleuthera, 1984
Oil on canvas
120 by 264"
Marlborough Gallery, Inc., New York

ELLSWORTH KELLY

I have wanted to free shape from its ground, and then to work the shape so that it has a definite relationship to the space around it; so that it has a clarity and a measure within itself of its parts (angles, curves, edges, amount of mass); and so that, with color and tonality, the shape finds its own space and always demands its freedom and separateness.

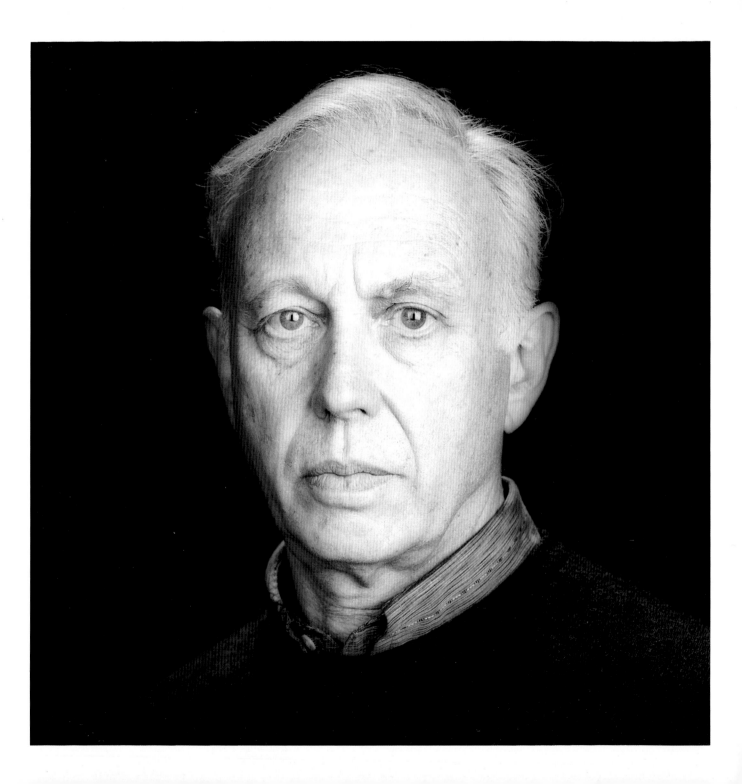

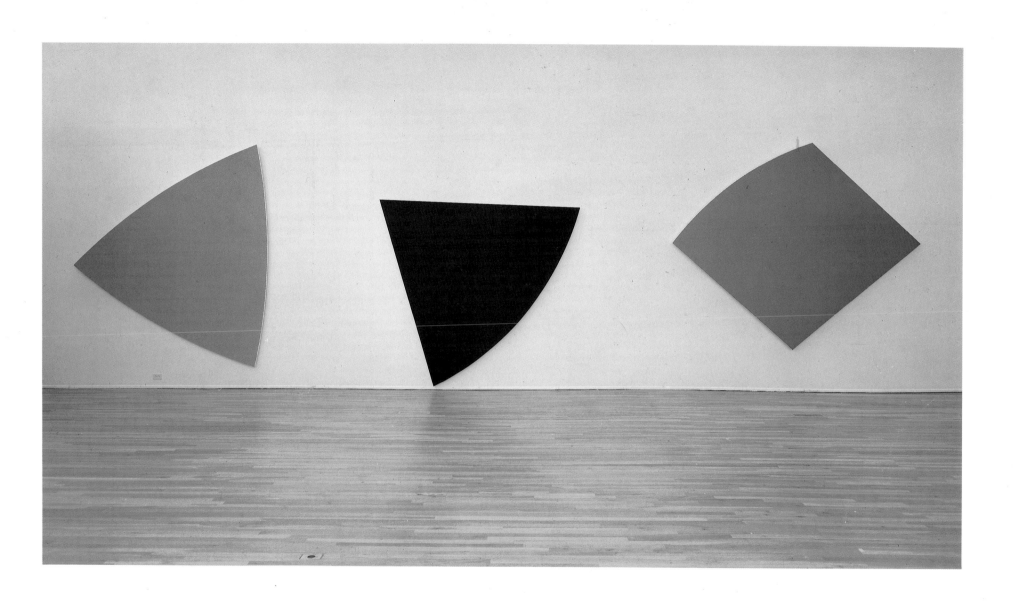

Orange, Dark Gray, Green, 1986
Oil on canvas
Three panels, 104½ by 90, 88 by 98, 97 by 118½″
Blum Helman Gallery, New York

65

ROBERT KUSHNER

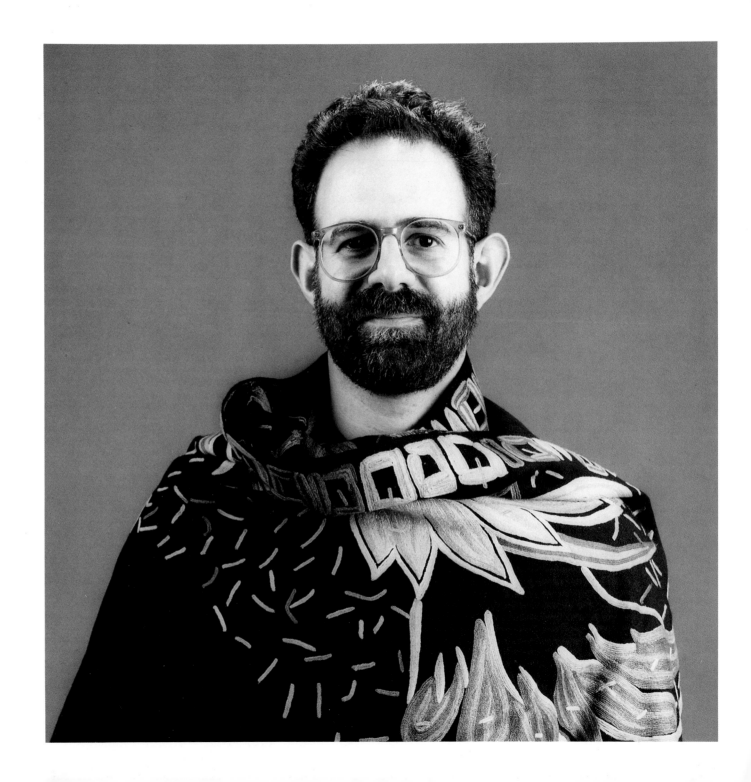

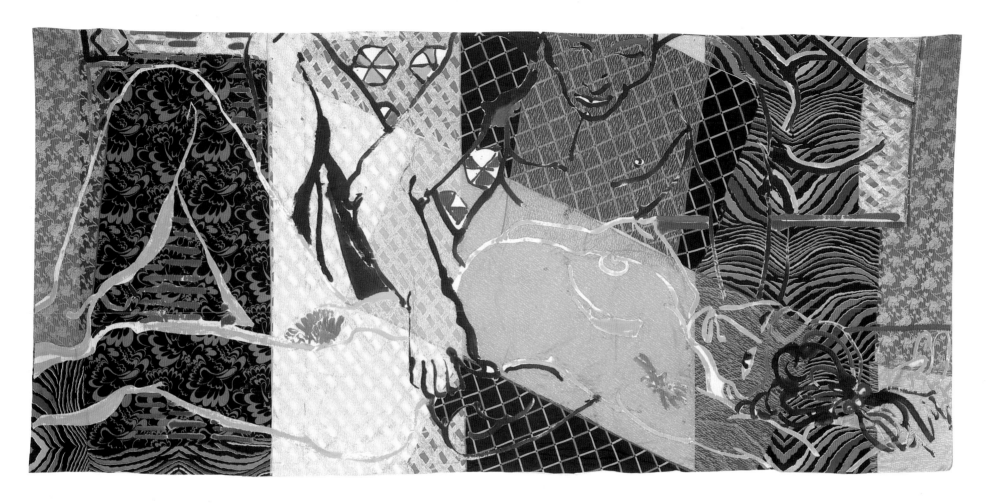

When you first start making art, everything is possible and desirable. Then the patterns of ideas start to emerge and you say, "What do I really want to do?" At that point in my artistic life, I discovered decoration with a vengeance; first, in the form of rugs and Eastern textiles; then, through them, Islamic architecture; and, rather accidentally, European fabrics, particularly of the eighteenth century. These objects all have one goal—to please the eye and thereby satisfy the human soul. Decoration's birthright is joy. It can also be sad, nostalgic, sober, even tragic. But it is always life affirming. The decorator tells us life is okay.

Decoration is an escape, or an open door to a momentary paradise. The decorator brings all of his or her mental capabilities and talents together to fulfill this mission. Anyone can make mediocre decorations. However, the real goal is to contribute to decoration's traditions with intelligence, urbanity, and power.

Tryst, 1983
Acrylic on cotton with sewn fabrics
102 by 216"
Holly Solomon Gallery, New York 67

ROY LICHTENSTEIN

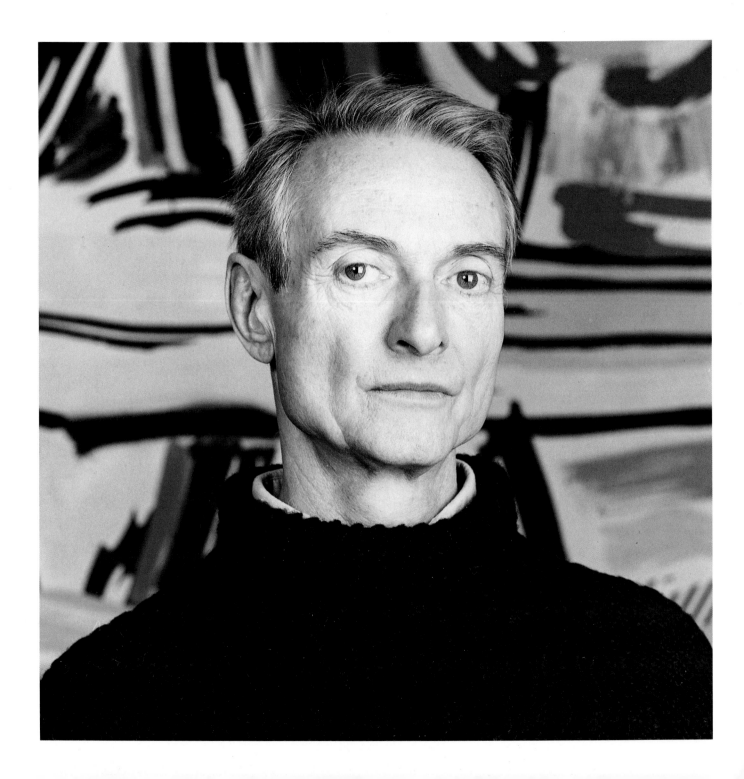

One of the characteristics of at least some German expressionism is the brushstroke, and in thinking about that I got into my first brushstroke landscapes—but they had only cartoon brushstrokes. Later there occasionally were spontaneous and cartoon brushstrokes in the same composition. The thing about adding the real ones was that the comparison would be right there, which meant a certain broadening of what I do. The paintings emphasize the brushstroke nature of painting that started perhaps with the Venetians. There was an emphasis on showing that you were doing a painting, not just an illusion of nature; and there was a certain bravura and style connected with the brushstroke. In the 1960s I did works in which I wanted the surface to be as plain as possible, but now I'm getting away from that, something more complex. In the 1950s I did hundreds of abstract expressionist paintings, so a degree of freedom isn't entirely alien to me. I like the contrast between the real and the cartoon brushstrokes, but the works are still calculated in the sense that each brushstroke is a single one that goes on in a particular way. Let's just say that the new pieces are spontaneous only in relation to me.

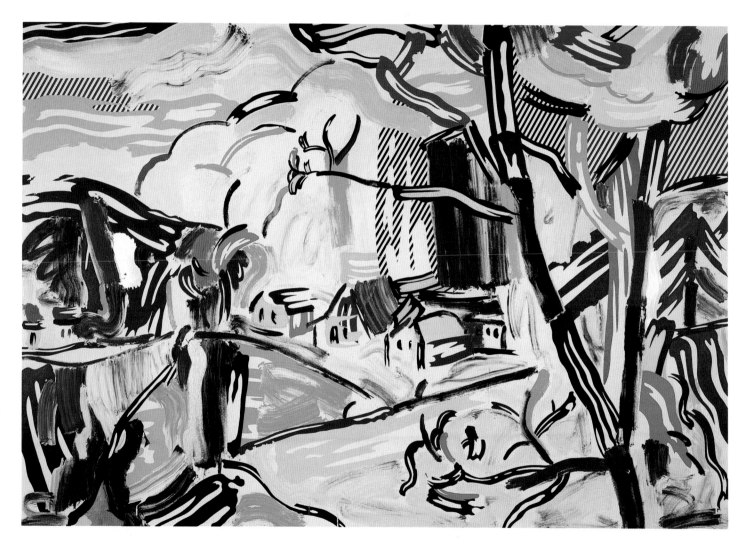

Mountain Village, 1985
Oil and magna on canvas
108 by 156"
Collection of Robert and Jane Meyerhoff

69

ROBERT LONGO

The works that incorporate building reliefs fulfilled my desire to bring the figures into a landscape. The buildings represent an acknowledgment of abstraction in the world. A building silhouetted against the sky is a simple relationship, like my figures against a blank background. *Final Life* is the concluding piece of the *Men in the Cities* series, and led to later work that became combines of different materials and multiple images on a large scale. I am interested in making art that extends beyond the idea of an individual's effort. Scale is important because there is a point in art at which scale can pull the art away from the maker. When you look at the Statue of Liberty, you don't think about who made it. I want the viewer to look at something that is both beautiful and horrifying. I am looking for a positive force in negative imagery.

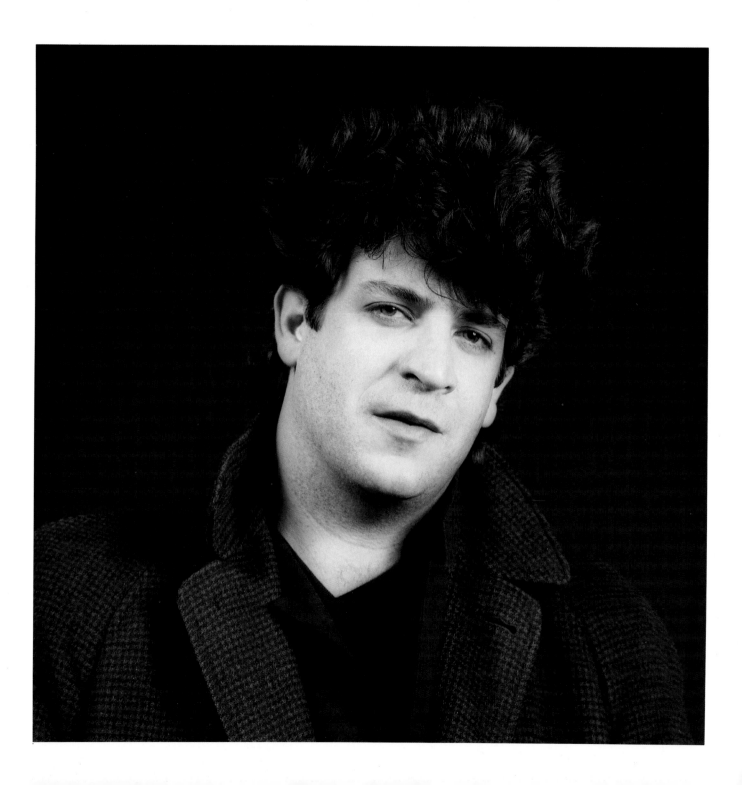

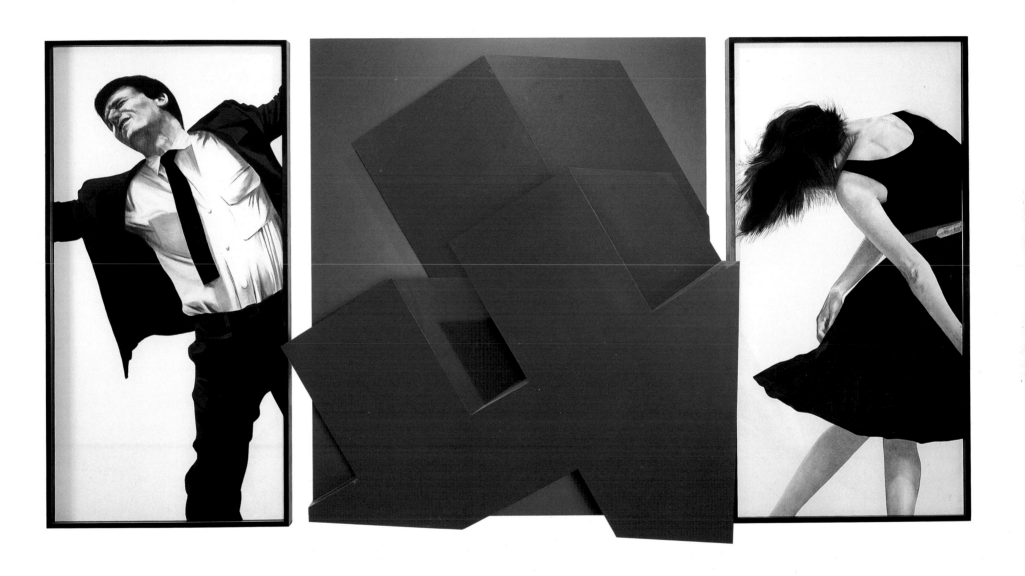

Men in the Cities: Final Life, 1981–82
Charcoal and graphite on paper, lacquered wood
96 by 168 by 31"
Private collection

ROBERT MANGOLD

I learned from abstract expressionism that art had content, that it signified something, that it was important. I am not interested in having my art depict, represent, preach, or prove a theory or tell a story, nor do I see it as particularly mathematical or cerebral. I see the artist as a kind of "image-maker" and by building constructs, which come from the mind and fill the senses, it is possible to create a work that has meaning. Each series of works that I have completed since 1980 has been both a step forward and also a reaching back for a connection with my earlier work. The work is centripetal in that it starts with a shape or edge and moves in by surface and structure, it surrounds and encloses.

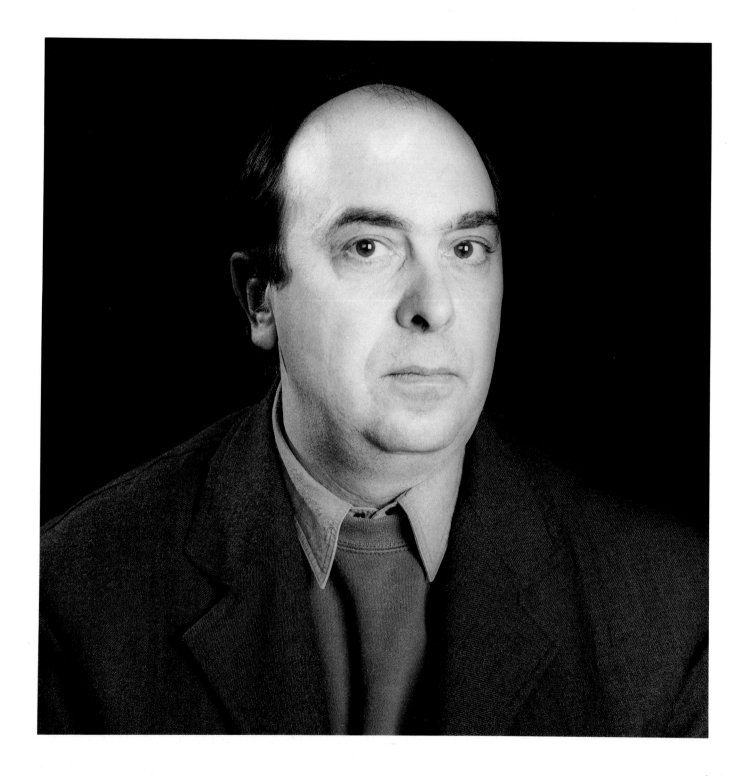

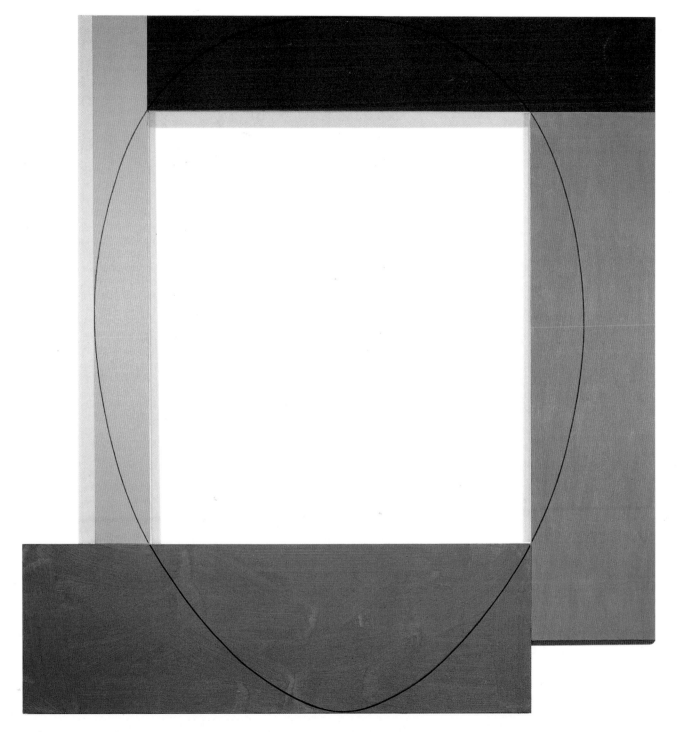

Four Color Frame Painting #1, 1983
Acrylic and pencil on canvas
111 by 105"
Collection of Martin Sklar

ROBERT MAPPLETHORPE

M y work is about seeing—
seeing things like they
haven't been seen before. Art is
an accurate statement of the time
in which it was made.

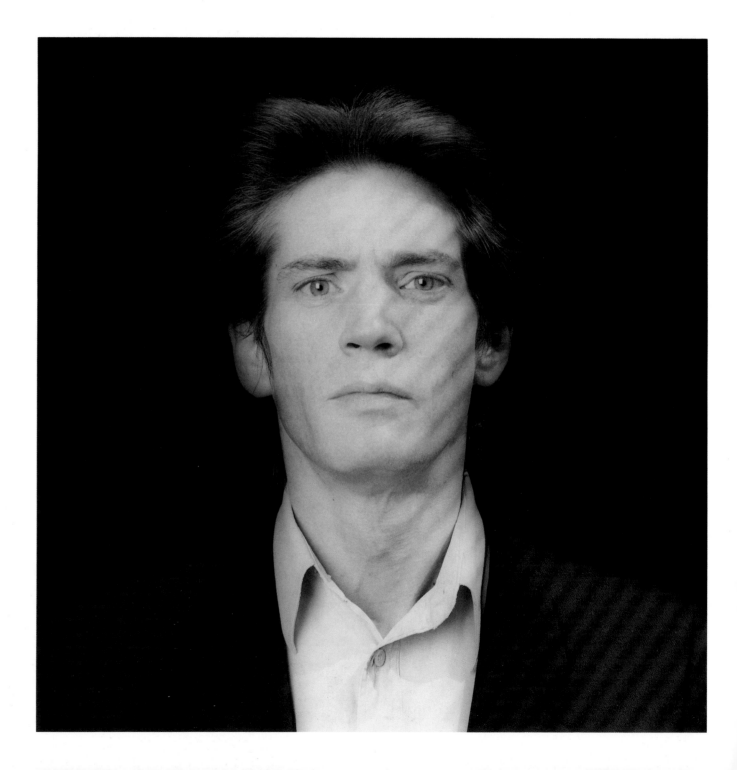

Ken Moody, 1984
Color photogravure
21½ by 17½"
Robert Miller Gallery, New York

BRICE MARDEN

'm painting on a flat surface, a two-dimensional surface, basically rectangular. That plane is created on that rectangular shape, and you work on that plane; you deal with illusion. But it's not illusion about things that you see. It's an illusion of an abstraction of things that you see. I'm not painting trees and flowers, even if I use a landscape image. A horizontal is a landscape image, vertical is usually a figure image. I paint nature. I mean, I refer to nature. I accept nature as a reality: it's the best reference, it's what the painting's about.

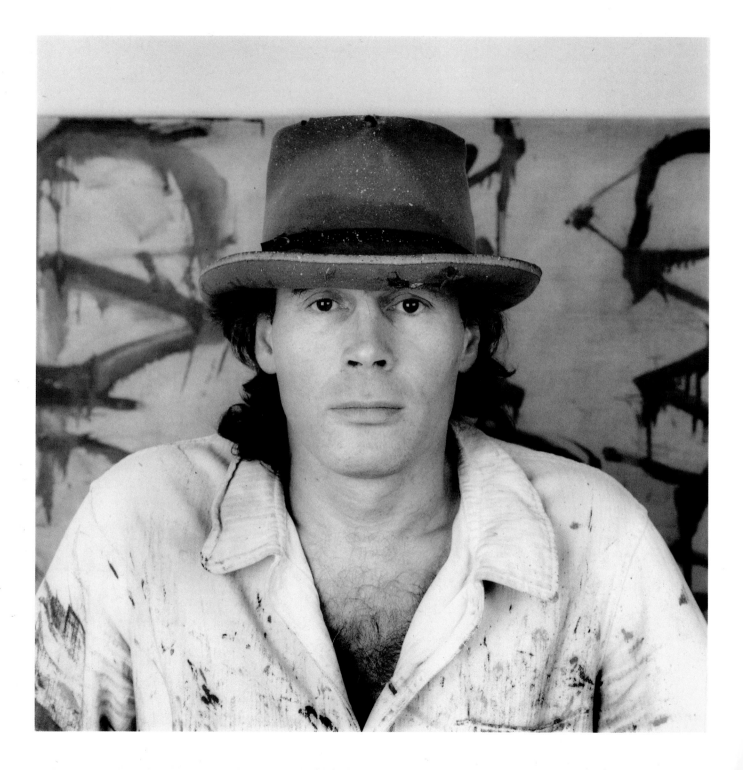

Number One, 1983-84
Oil on canvas
84 by 109"
Whitney Museum of American Art, New York; Purchase,
with funds from the Julia B. Engel Purchase Fund

MALCOLM MORLEY

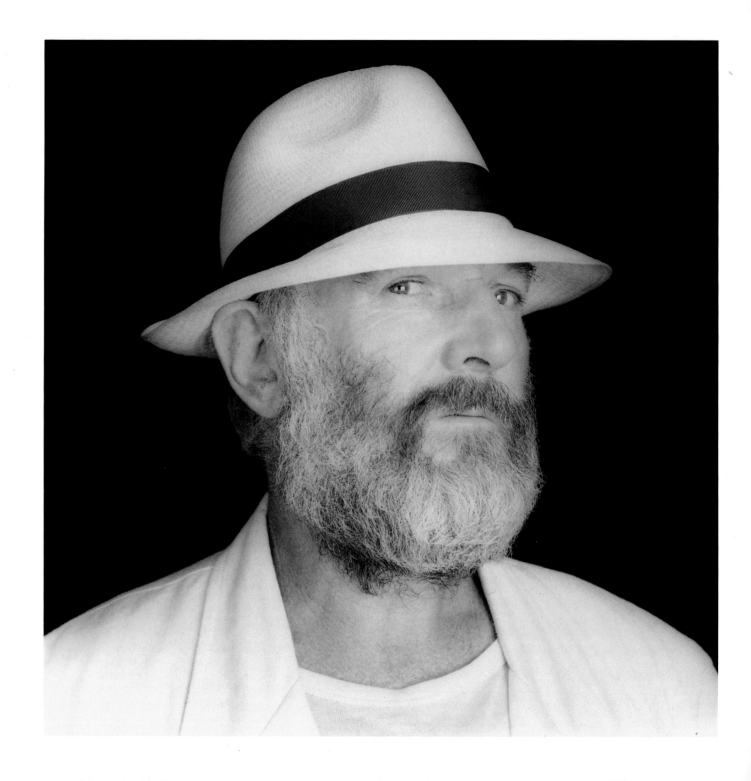

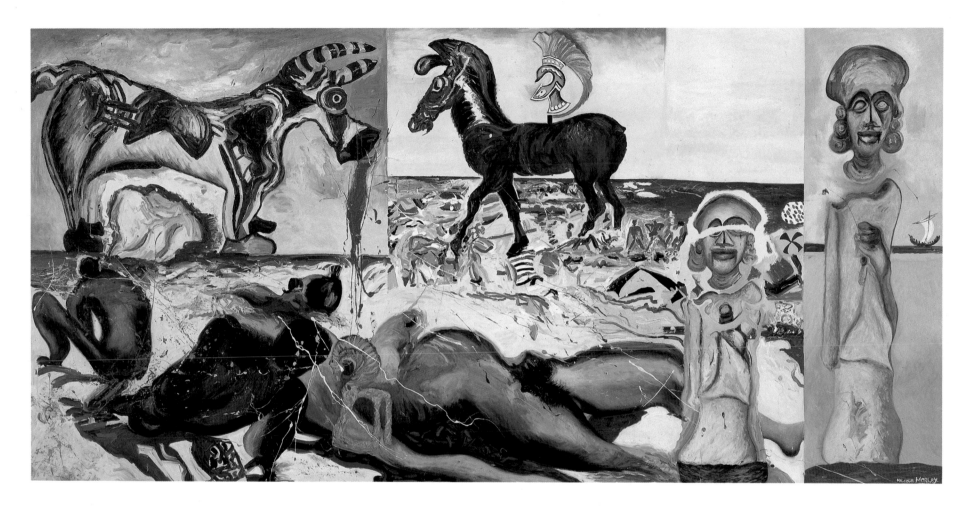

I am walking with my stepfather and talking about playing cricket, mainly about bowling, which he's forgotten. I remind him how we used to play a lot. I then demonstrate how one bowls with a lump of clay. As I do, it takes on a shape that's like part of a wheel, that's very textured. I place particular emphasis on how you get a spin by twisting the wrist. I am then in an art school, not as a student, looking for someone to help me cast the clay. The clay is gray, the same as wall compound. It breaks into two parts; one is the stem, the other the spindly fragments of the wheel. I keep asking if there is a teacher. I then think it should go into a refrigerator to keep it firm for casting. I have a wonderful feeling I've made my first sculpture. My stepfather had forgotten we played cricket; there is a great feeling of excitement. It gleams as if wet, and looks like metal although it is clay. I want to reproduce it by making a mold of it, rather than use it as a model, and work directly in steel. I mention casting it in bronze.

The sculpture was born of the velocity of the swing.

ROBERT MOSKOWITZ

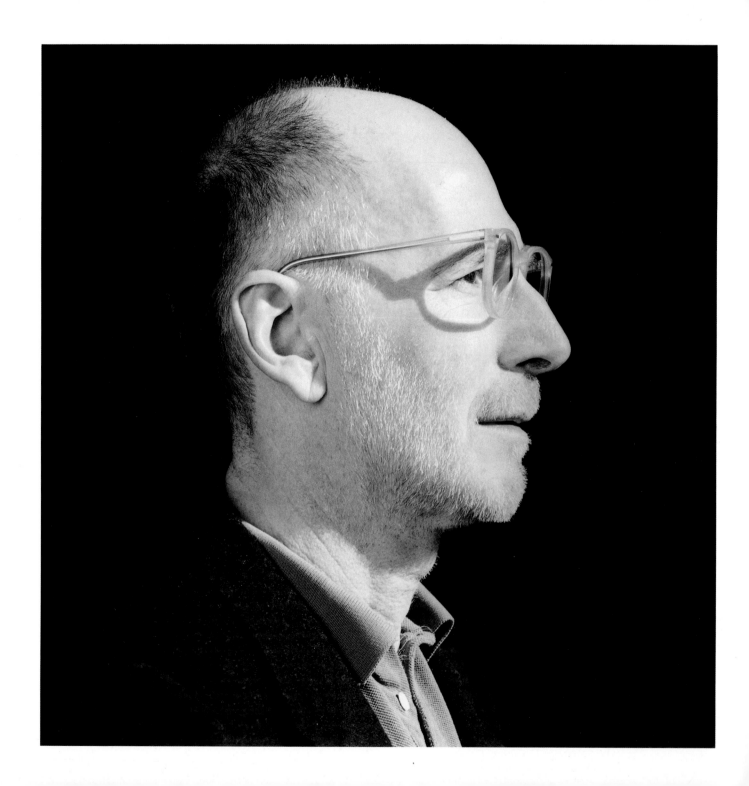

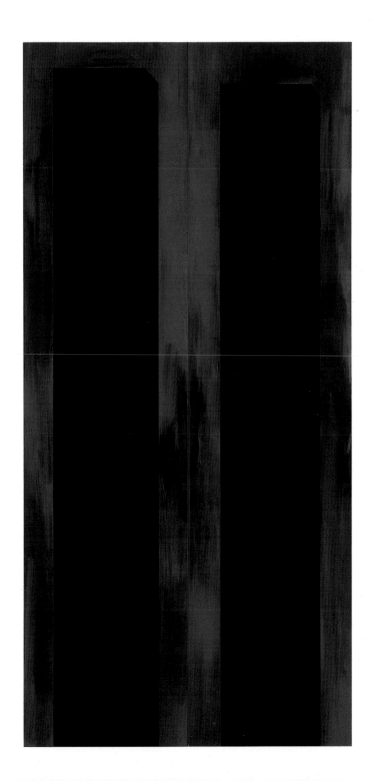

The buildings and objects I paint relate to people. I also think of the *Skyscraper* painting as two people. This is the third *Skyscraper* I've done since 1978 and each is different, and a reproduction is different again.

Skyscraper III, 1984
Oil and latex on canvas
122 by 58″
Private collection

ELIZABETH MURRAY

A *rt Part* is one of two shatter
paintings. I was imagining a
whole thing—dropped or fallen
and then shattered—on the
ground, in the air, or perhaps in
the body or mind. The image
inside is trying to form the pieces
whole again. The image is a hand
(or just a globby shape) reaching
for a dripping brush. So it is
about the mundane painting
"actions" well known to a
painter. The psychological mean-
ing of the painting for me is my
own conscious and unconscious
efforts to bring disparate, conflic-
tive parts of (my) self together. I
think I also wanted to paint about
my sense of art in the world at
this moment, and what its mean-
ing as an activity and then as an
object might be.

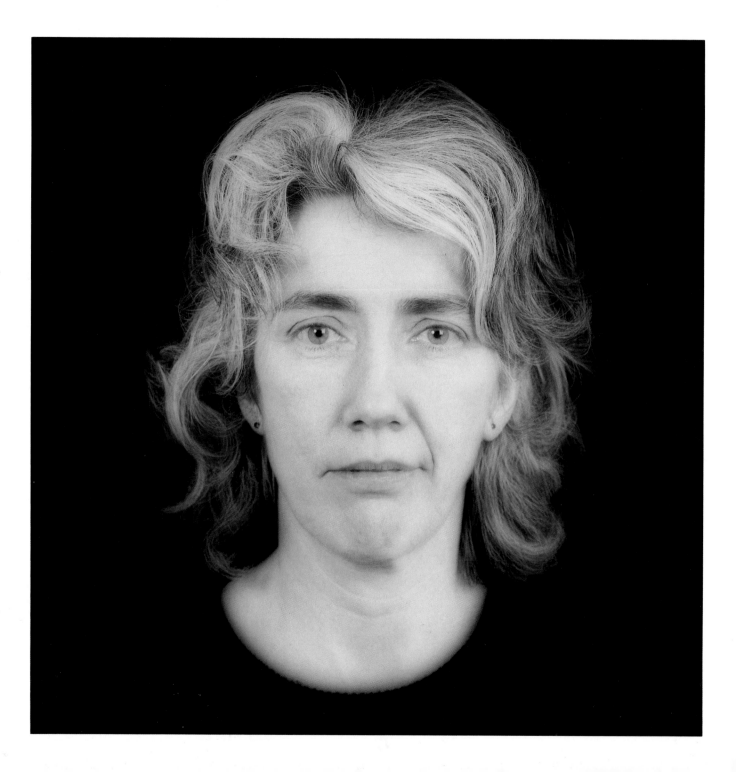

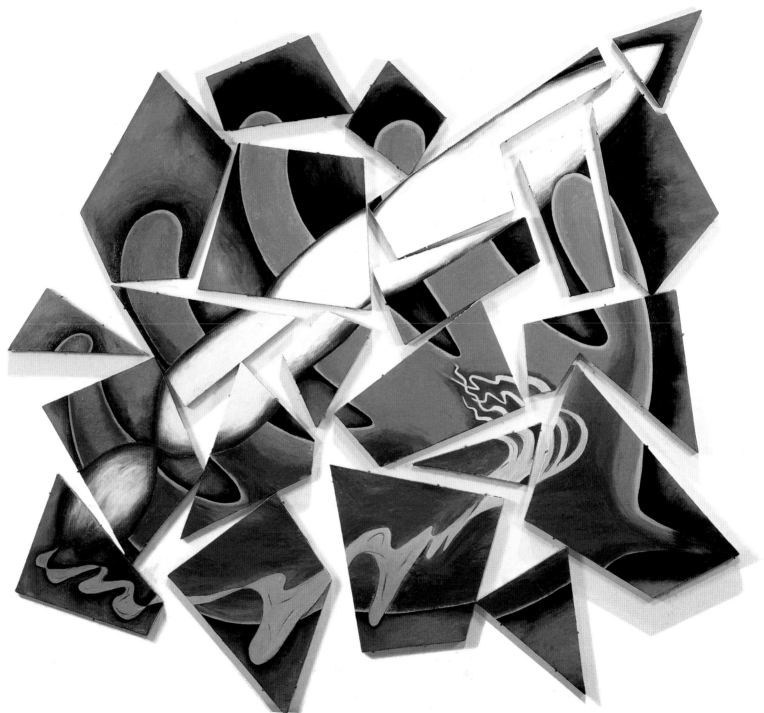

Art Part, 1981
Oil on canvas
115 by 124″
Private collection

LOUISE NEVELSON

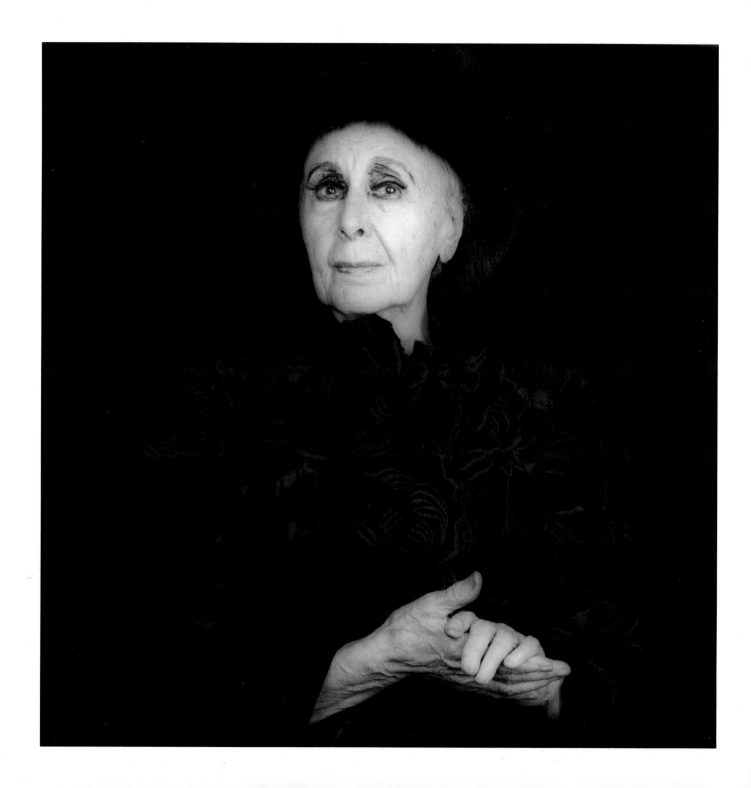

I give as much weight to shadow as to the object that the shadow comes from. In other words, I'm aware of the shadow as the substance of the piece. My basic interest and my project of life, or what I've tried to do, is to achieve oneness. In dawns and dusks, there's a circle. I think the thing for me was getting to a place—its oneness, probably on a spiritual level. I might say that I look back, over my eighty years, and I feel that there has been a unity in spite of everything. And what was the unity? It was art. Whatever I touched in art gave me confidence. There hasn't been a day in my life when I doubted whether I was an artist of the kind I am. At first I had to do everything—find the wood, carry the materials, make it— and today I have help. It appears that I'm doing more, but it's about the same. I think that what I—as one person—had to say on earth, I've said and said it well. I have come as close to what life is as is possible for a human being. I just probably want more or less what I have done.

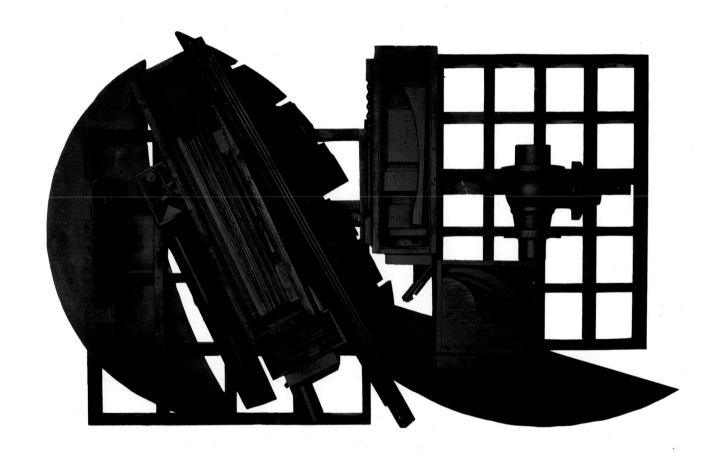

Mirror-Shadow XVI, 1985
Painted wood
61 by 109½ by 15″
The Pace Gallery, New York

ISAMU NOGUCHI

Through the artist's hand we arrive at a different epoch in the history of the primordial stone. All that I do is to provide the invasion of a different time element into the time of nature. My marks and modeling are a kind of definition in an undefined nature of our incursions. It represents a contract between myself and nature. All of my pieces have been an investigation of the inside. They are a kind of research into the stone. Brancusi really found what lay at the heart of stone or his bronzes. Inside was a beautiful heart of bronze or stone, which shines like the sun. He brought back the discovery of the material itself. What I am doing is a similar sort of thing. I am always looking for a new way of saying the same thing.

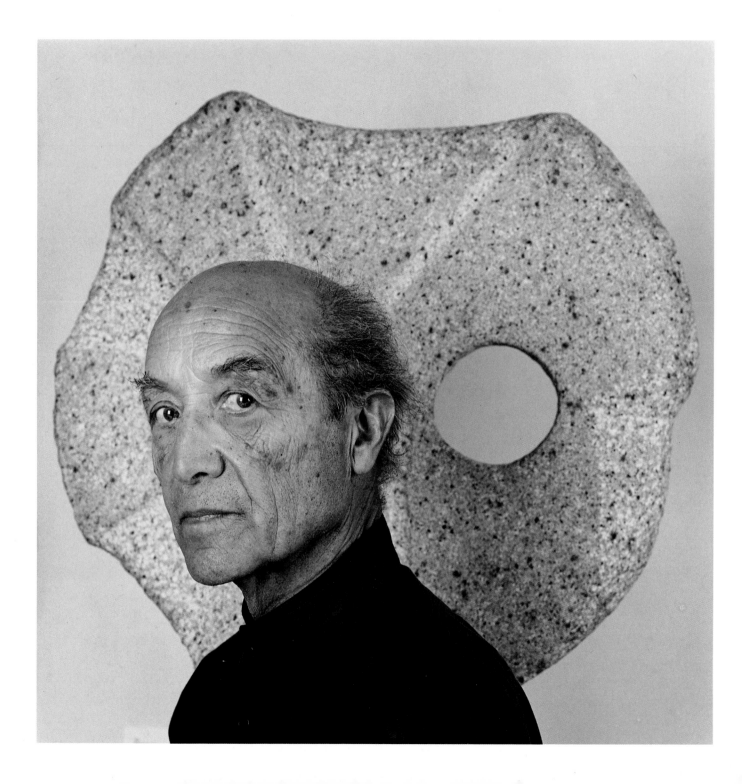

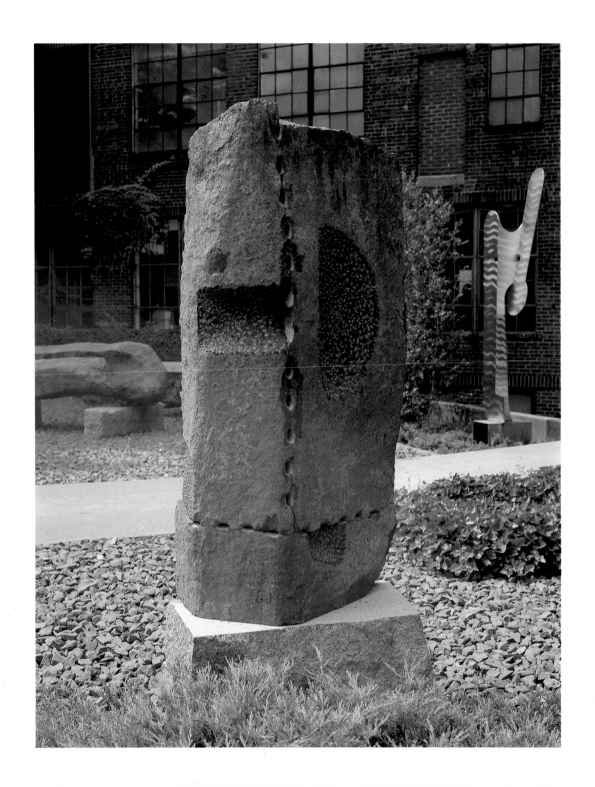

Entry Way, 1983
Basalt
64 by 33 by 15"
Isamu Noguchi Garden Museum, Long Island City,
New York

87

PHILIP PEARLSTEIN

I try to find a compositional structure in the subject itself, in nature. It is a kind that relates to the structure I read in the paintings of, say, de Kooning and Franz Kline, and develops from the way the forms move across the surface of the canvas. I look for a clash of the main axes of the primary forms. Diagonal, opposing movements result from the way the models are posed and how their forms move against the pieces of furniture. I rely on the angle where the wall meets the floor as a constant reference point, and against that I oppose the movements of the model's limbs. With the addition of furniture, draperies such as Japanese kimonos, or patterned rugs, other movements are created, and the relationship between forms is made more complex. The color I use results from an attempt to be as accurate in depicting the color of the forms as

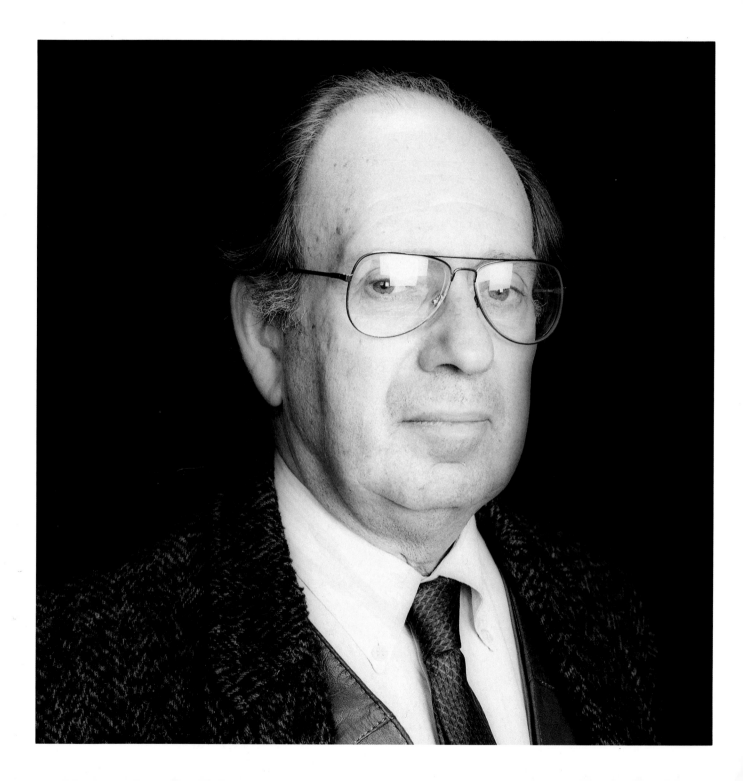

I am in drawing their contours. The use of rugs, pieces of furniture, and kimonos brings in a greater range of colors and textures. Over the twenty-odd years I've worked this way, I have deliberately tried to concentrate on the formal problems of representational painting. I have tried to remain emotionally removed, not to become subjectively involved in presenting the human form. I would prefer to have my paintings "read" as moments in dance, in which the aesthetic of forms moving through space is seen as the motif, rather than as storytelling. However, no artist can really control what people read in the work. A certain "look" is produced by the way the work is developed, and meanings on a subjective, unconscious, and ambiguous level somehow emanate. That is the poetry of painting.

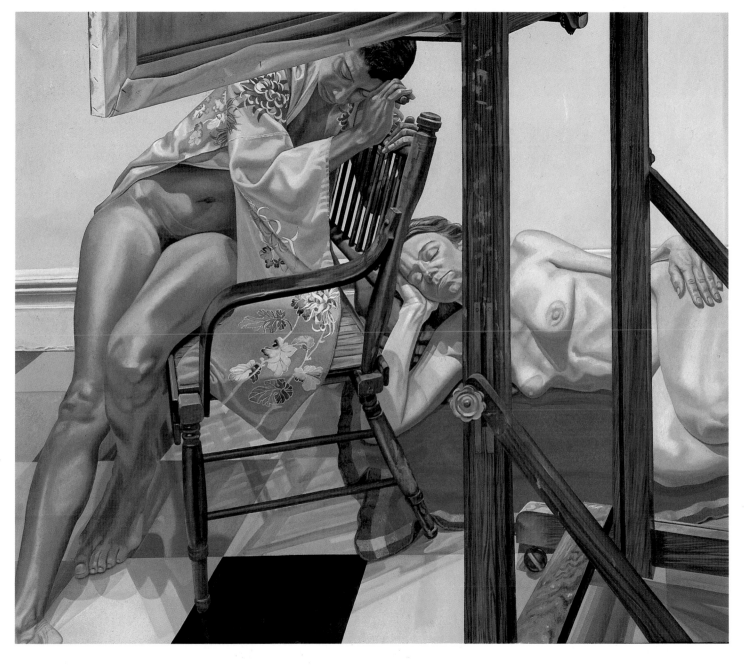

Two Models from the Other Side of the Easel, 1984
Oil on canvas
72 by 96"
Hirschl & Adler Modern, New York

89

JUDY PFAFF

I am interested in opening up the language of sculpture as far and as wide as I can in terms of materials, colors, and references, and in trying to include all the things that are permissible in painting but absent in sculpture. By attempting to achieve a certain type of speed that is traditionally reserved for painters, I'm reaching for a crossing over of ideas and a weaving of thinking and making. Peripheral vision is and always has been crucial to my work because there is a false sense that you know it if a work can be seen all at once. I often incorporate tree branches into the installations, and they are usually the freest aspect of my work. Most parts of my work are controlled and muscled into place, but there also exists a natural, beautiful line. It is important that the work has a balance of enough artifice and enough casualness, and enough surprise and enough reason.

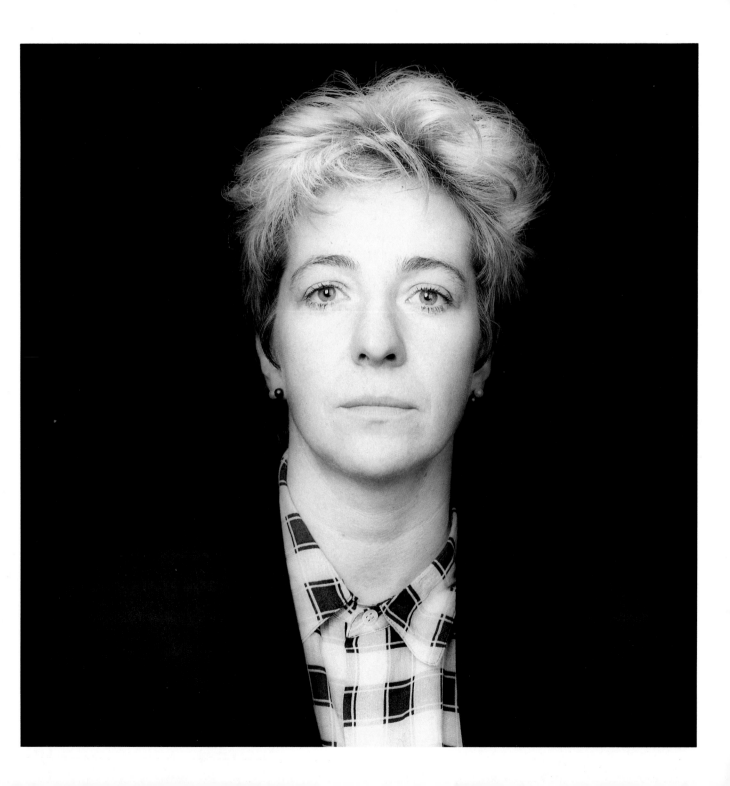

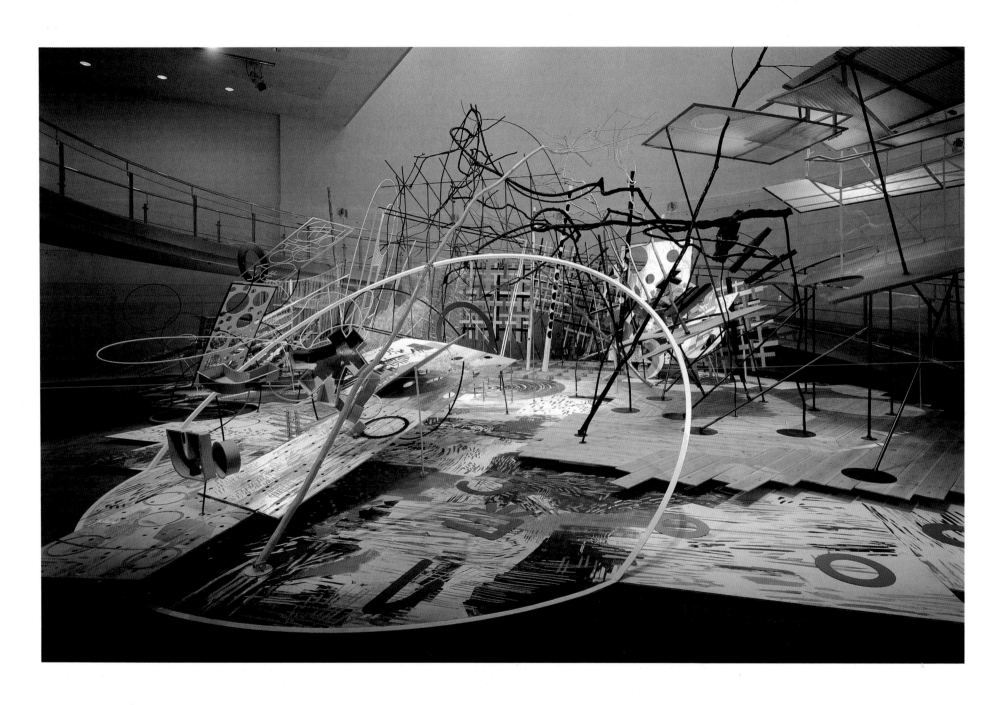

Gu-Choti Pa, 1985
Painted wood, steel, plastic
40' diameter by 20' high
Collection of Wacoal Art Center, Tokyo

JAMES ROSENQUIST

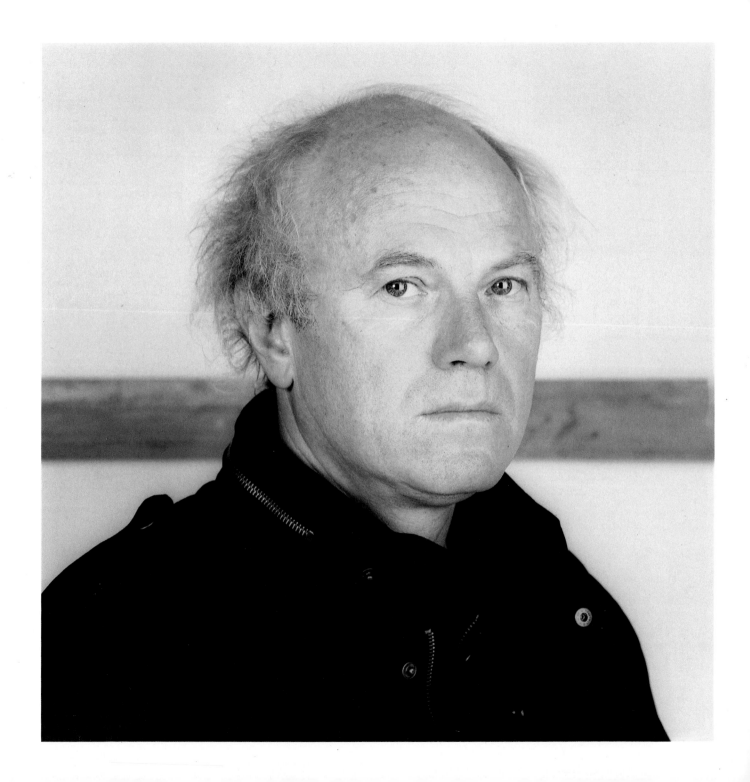

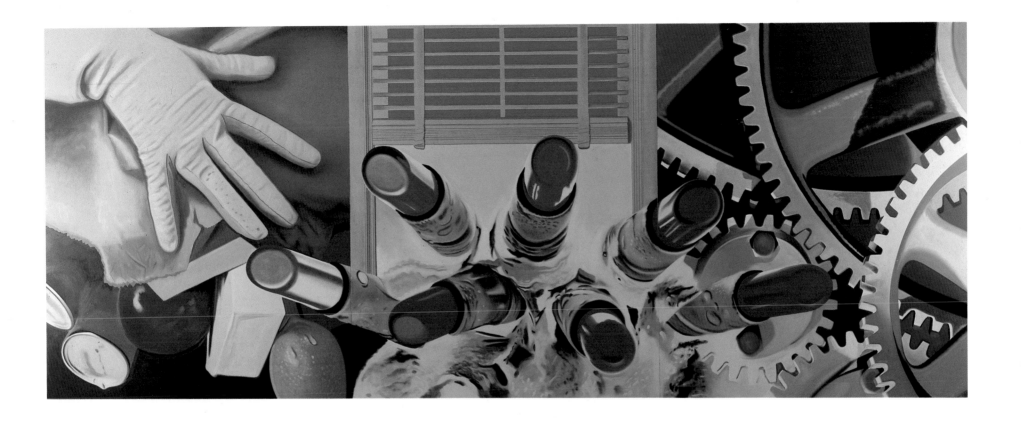

House of Fire II, 1982
Oil on canvas
78 by 198½"
Collection of Emily Fisher Landau

n 1960 I wanted space in a picture that would spill off the surface, be larger than life. I don't think I'm a realist because I focus on an object because it is an object. It's the part of the object, like a big arabesque in an Old Master painting, that's the emphasis. And where the emphasis is, is also where the emotions, the color, and everything else exists. The magic of painting is when you turn a canvas on its edge, and it is only one-sixteenth of an inch thick on an old piece of linen. I'm excited by all that illusion and color that comes from just moving minerals mixed with oil around on a surface. In this age of technology, there are still more digits in a Chinese bristle brush and a human brain than there are in a computer. I often think of art in a tomb. I try to develop something pictorially, without sound or movement, that will communicate visually directly. The idea is to have the picture communicate so that all the spectator needs is to bring his or her intuition and the light of day. If the fuses blow, it will still look good.

SUSAN ROTHENBERG

olding the Floor is about an imagined moment in a real person's fantasy based on fact; thus its complexities involve perceptual and psychological memories based on real and imagined experiences. The results are a way of discovering what I know and what I don't, what I didn't know I knew, and what I want to learn—which are things that seem close to unpaintable, which is why I love painting, which is not quite like the donkey and the carrot, but close.

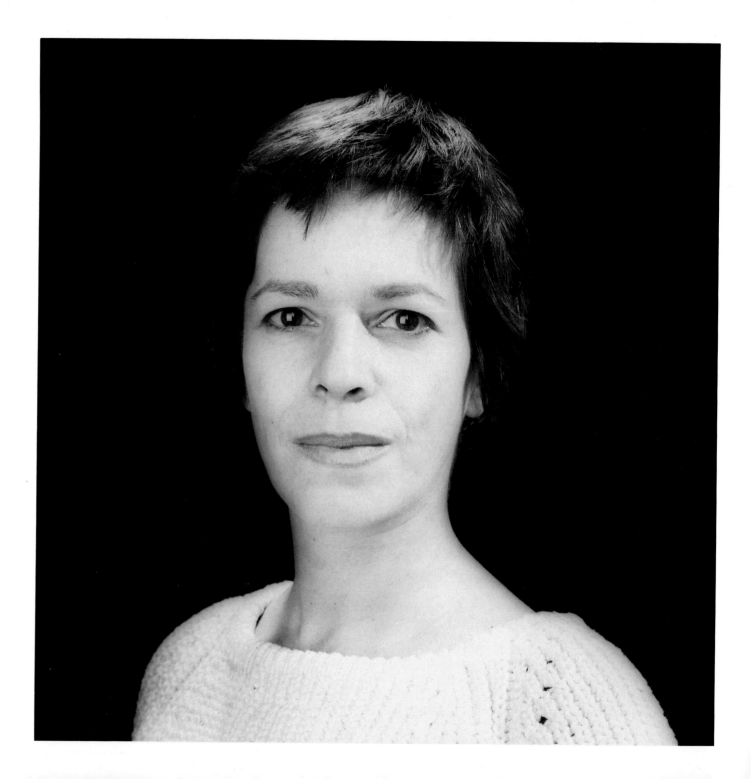

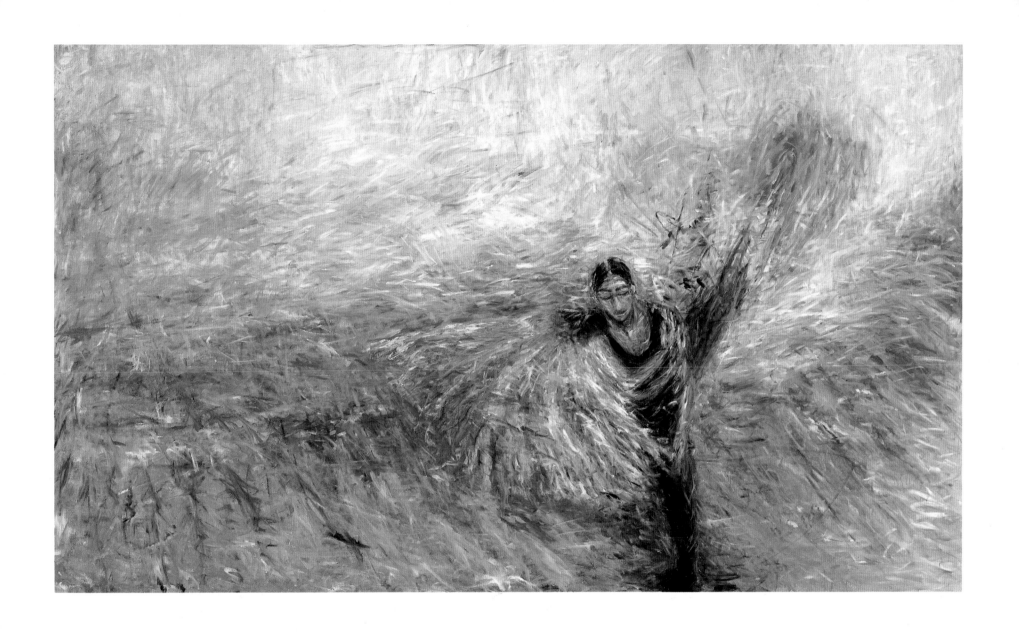

Holding the Floor, 1985
Oil on canvas
84 by 147"
Willard Gallery, New York

DAVID SALLE

I am primarily interested in character formation: things like how you know what to do or what to say.

Some attention has been focused on the origins of the elements in my paintings. The source is usually not very interesting to me; all images come from somewhere. Sometimes they come from things I've drawn or observed, or things I've set up so that they could be observed. It's not the case that they come from anywhere: to focus on where the images come from distorts their life together *in a painting*.

There is a process that is related to looking at paintings by which something is transformed from a point of empathy to a point of detachment and vice versa. That kind of reciprocity in one's emotional life feels lively to me. Images, once in paintings, are not just styles, but facts. That can feel very freeing.

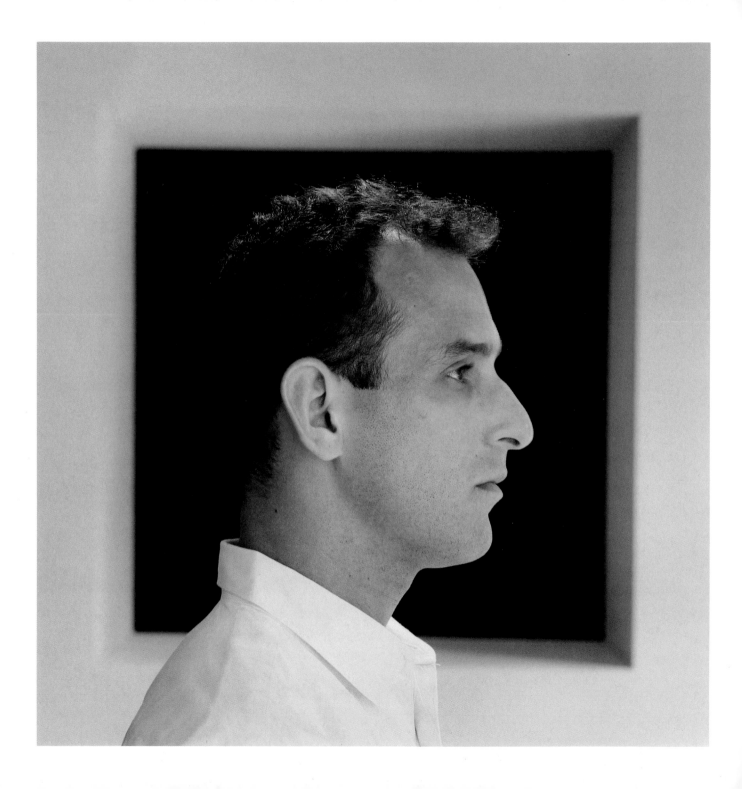

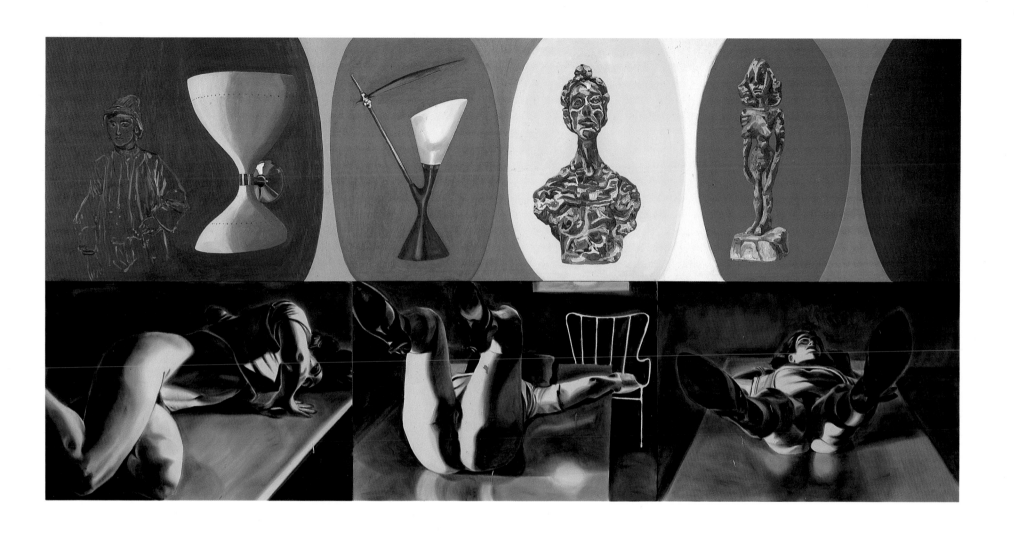

Fooling with Your Hair, 1985
Oil on canvas
88½ by 180¼″
Private collection

KENNY SCHARF

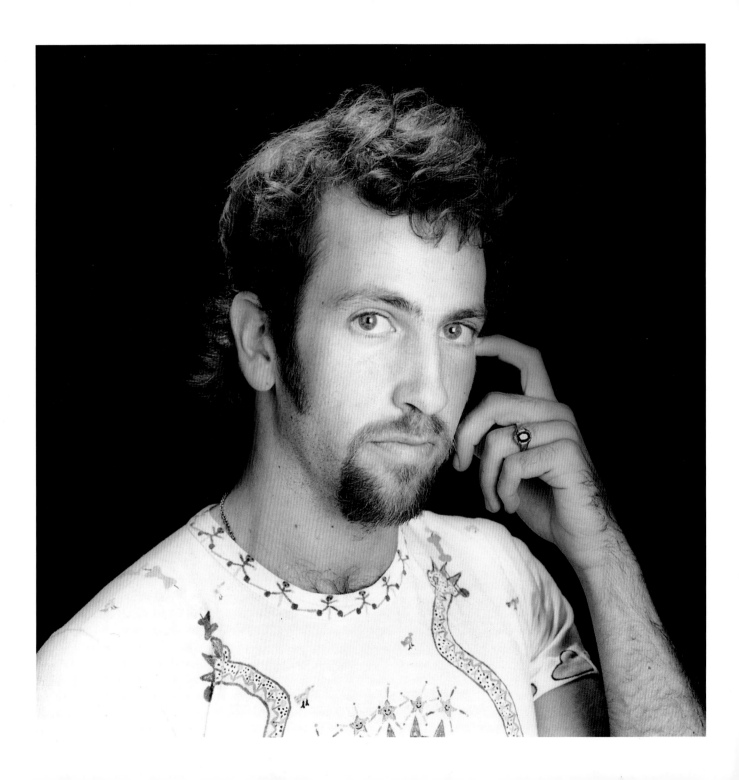

When I start a painting, I often get ideas from a dream, but usually it's more from things I'm thinking about all the time. I don't make drawings first, I just start. I use acrylic and spray to start the background. I use oil paint, too— I like the way it looks wet—and I finger-paint a lot. I can't really make a mistake because I can use a mistake, keep going, and transform it. There are many childlike things in the paintings. Children are uncalculating, and I try to get that quality in the work. I also think about outer-space things a lot. When I was little, in the early 1960s, the whole outer-space look was in cars and furniture and everything, and I think that time was the best. I like bright colors, the brighter the better. When I was seven, we got our first color TV, and I would sit very close and see the dots of intense colors. That's the kind of color I like. I want to have fun when I'm painting, and I want people to have fun looking at the paintings.

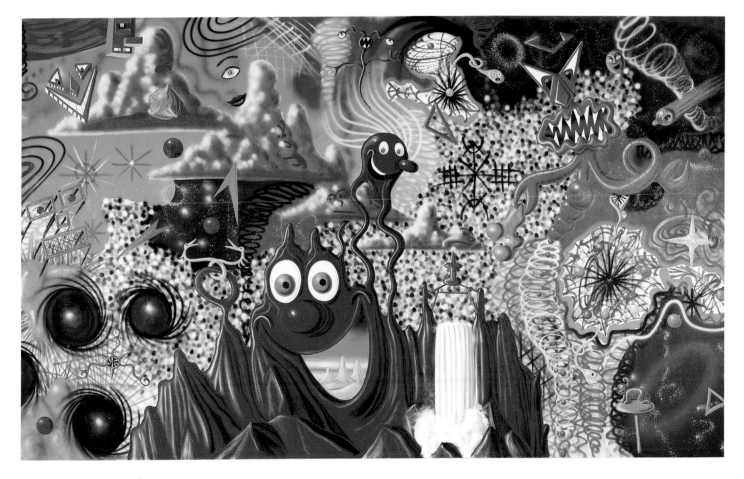

When the Worlds Collide, 1984
Oil and enamel spray paint on canvas
122 by 209¼"
Whitney Museum of American Art, New York; Purchase,
with funds from Edward R. Downe, Jr., and Eric Fischl

JULIAN SCHNABEL

The materialism of things just summons up something that is outside of them, which is the art, which is the feeling of beauty. I don't know what the face of beauty is, but I know what it feels like after I've seen it. I'm going to remember it. "Beautiness" seemed like a phantom to me, a holograph, something hovering without gravity. When I was a kid, I used to make drawings on paper and I would think they weren't thick enough or big enough or round enough. The paintings were too flat for me. I couldn't feel them. I wanted to make little heavy objects, whose weight I could feel; an object that I could hold in my hand, like a club. When I got bigger, the paintings became bigger. They had weight. They satisfied a need for some kind of bulkiness, a thing that was like another body.

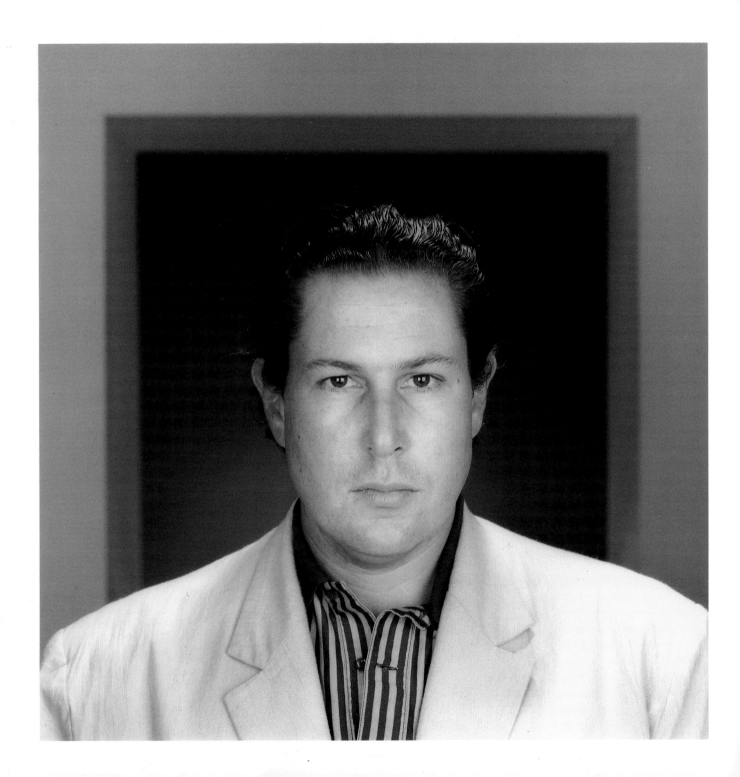

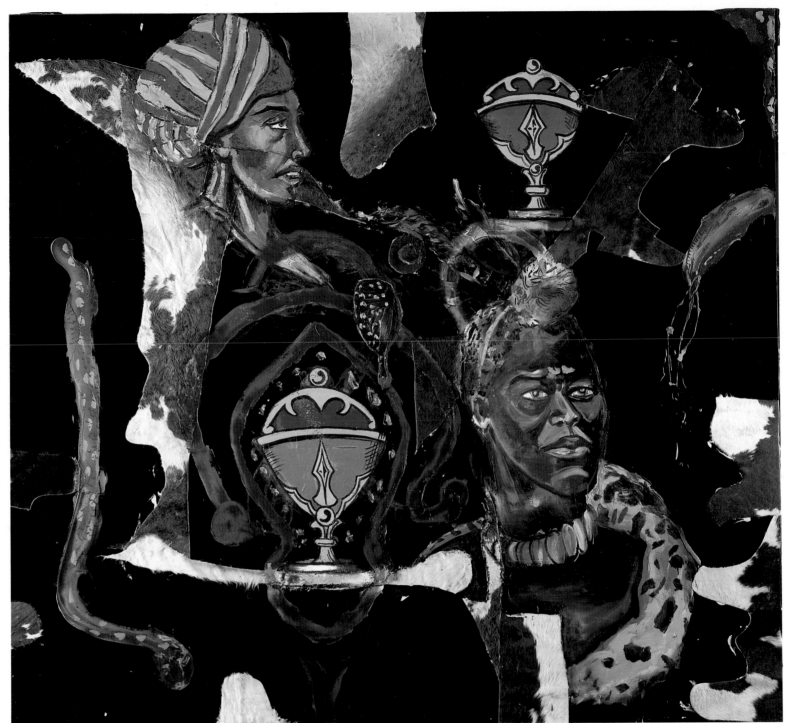

Ethnic Types #15 and #72, 1984
Oil and animal skins on velvet
108 by 120"
The Pace Gallery, New York

101

GEORGE SEGAL

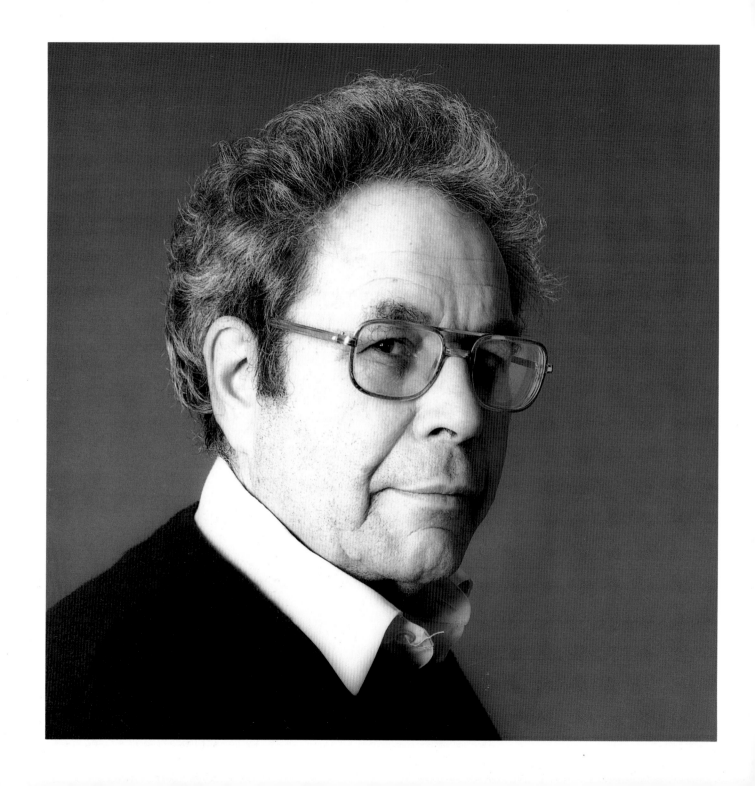

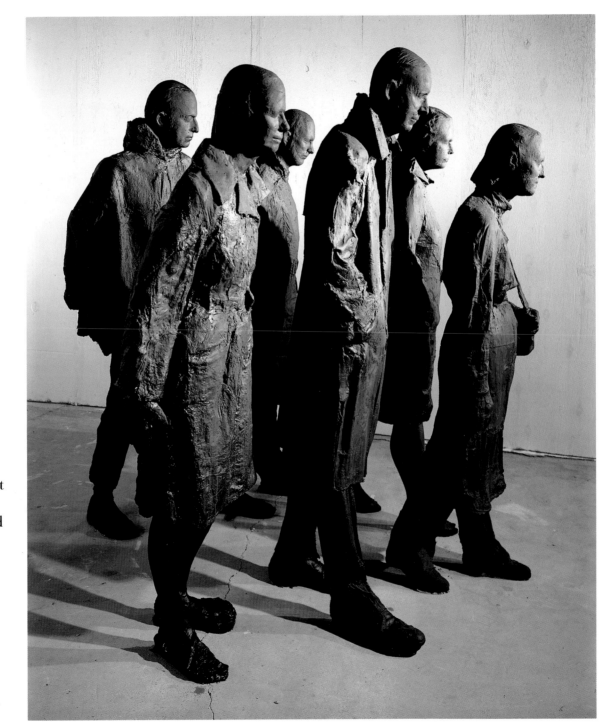

I want to walk into a second world of my own making peopled with friends and ordinary objects, ordinary places that are somehow charged with the invisible yearnings, passions, and thoughts of daily life.

Rush Hour, 1983
Bronze with patina on concrete base
72 by 96 by 96"
Sidney Janis Gallery, New York

RICHARD SERRA

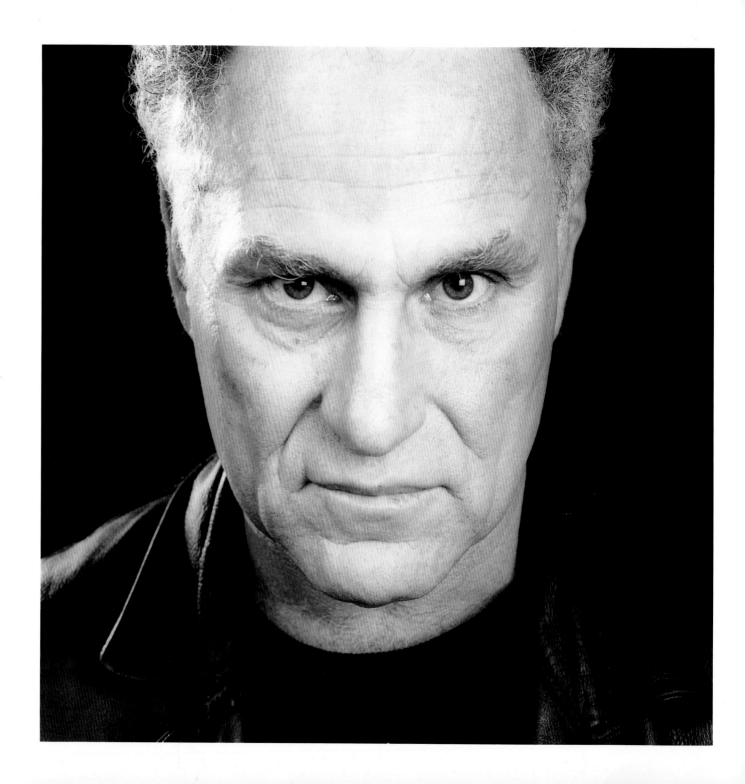

My large-scale pieces in public spaces are often referred to as being monumental and oppressive, yet, if you look at these pieces, are you asked to give any credence to the notion of the monument? Neither in form nor content do they relate to the history of monuments. They do not memorialize any person, place, or event. They relate solely as sculpture. I am not interested in the idealization of the perennial monuments of art history, emptied of their historical function and meaning, being served up by architects and artists who need to legitimatize their aesthetic production by glorifying past historical achievements. I am interested in sculpture that is nonutilitarian, nonfunctional. Any use is misuse; if a work is substantial, in terms of its context, then it does not embellish, decorate, or point to a specific building, nor does it add to a syntax that already exists. In my work I analyze the site and determine to redefine it in terms of sculpture, not in terms of the existing physiognomy. I have no need to augment existing contextual languages. I have always found that that leads to application. I'm not interested in affirmation.

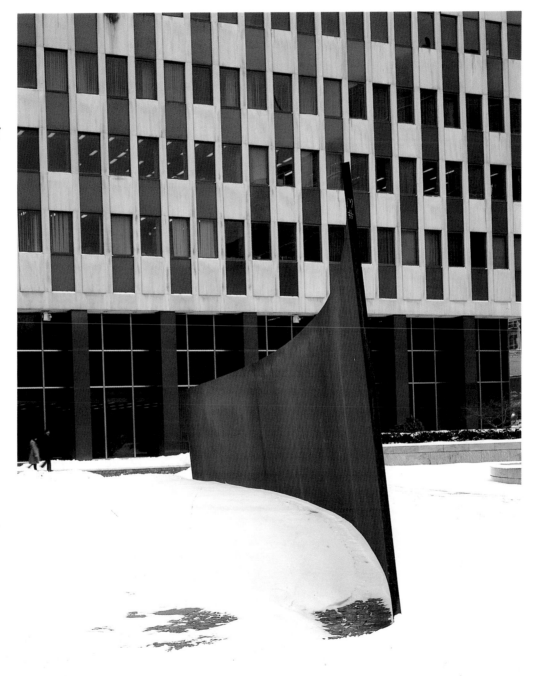

Tilted Arc, 1981
Corten steel
12 by 120'
General Services Administration, Federal Plaza, New York 105

JOEL SHAPIRO

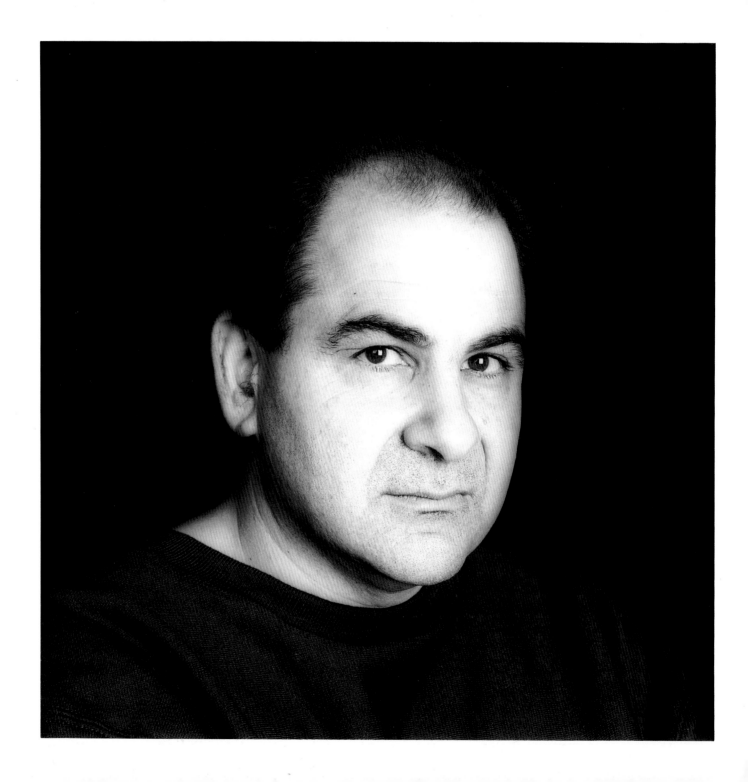

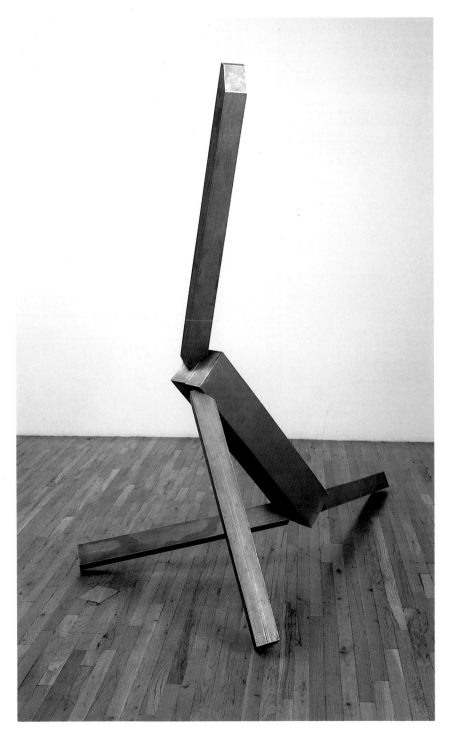

Verticality is an issue in sculpture. How do you get mass off the ground and into the air?

First, I made a cantilevered piece composed of three elements. The leg, anchored to the ground, meets the chest at an obtuse angle. The chest, a blockier rectangle, parallels the ground but angles slightly upward. The arm extends, reaching upward again from the chest. The piece was linear. It read fast.

I took the same configuration again—two sets of the same elements—and tossed them, one on the other, so the two chests compress and double and the limbs extend, wheeling away from the center.

Then I flipped the piece over so it rested on the linear elements. This is what I wanted: a figure that ascends and descends simultaneously, independent of an anchor.

Untitled, 1985
Bronze
90¼ by 89¾ by 52½"
Paula Cooper Gallery, New York

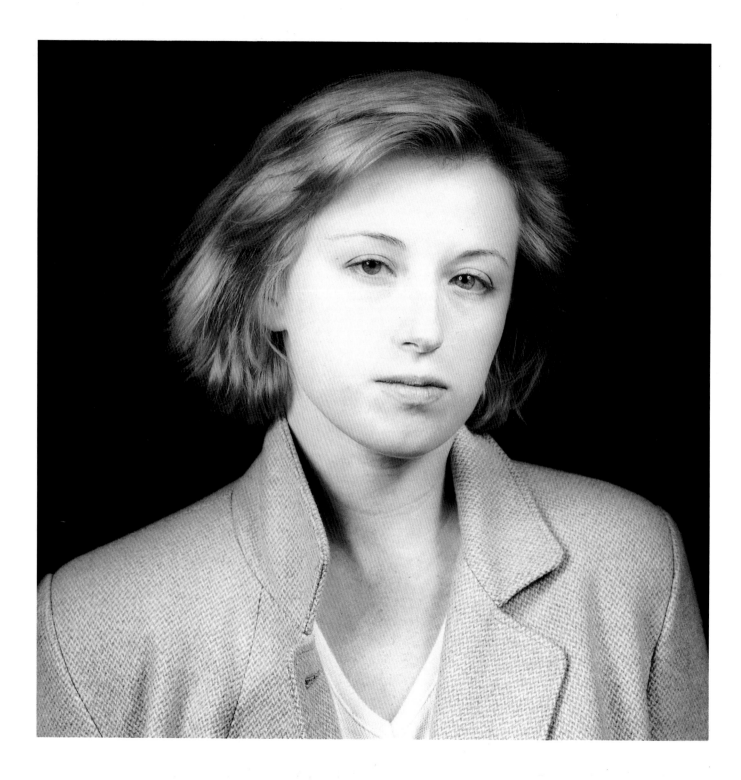

I want that choked-up feeling in your throat which maybe comes from despair or teary-eyed sentimentality: conveying intangible emotions. A photograph should transcend itself, the image its medium, in order to have its own presence. These pictures of emotions personified, entirely of themselves with their own presence—not of me. The issue of the identity of the model is no more interesting than the possible symbolism of any other detail. When I prepare each character I have to consider what I'm working against; that people are going to look under the make-up and wigs for that common denominator, the recognizable. I'm trying to make other people recognize something of themselves rather than me.

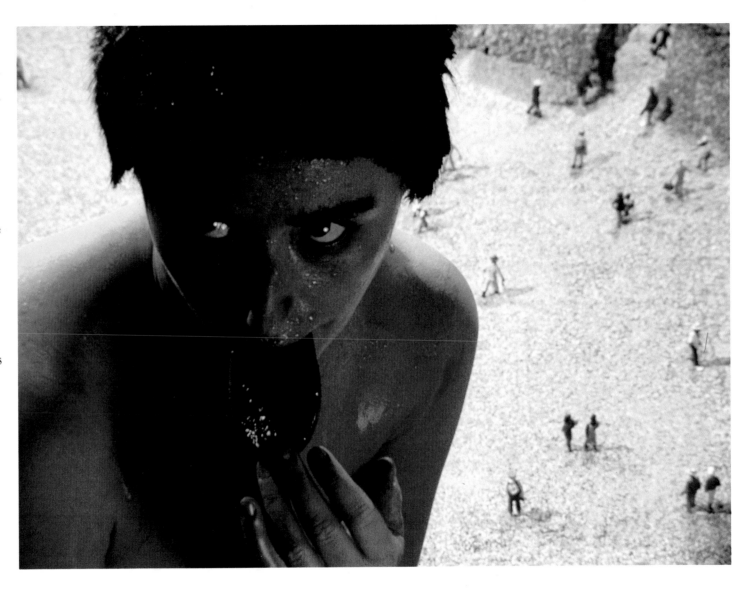

Untitled, 1985
Color photograph, Cibachrome print
49½ by 66⅓″
Metro Pictures, New York

ANDY WARHOL

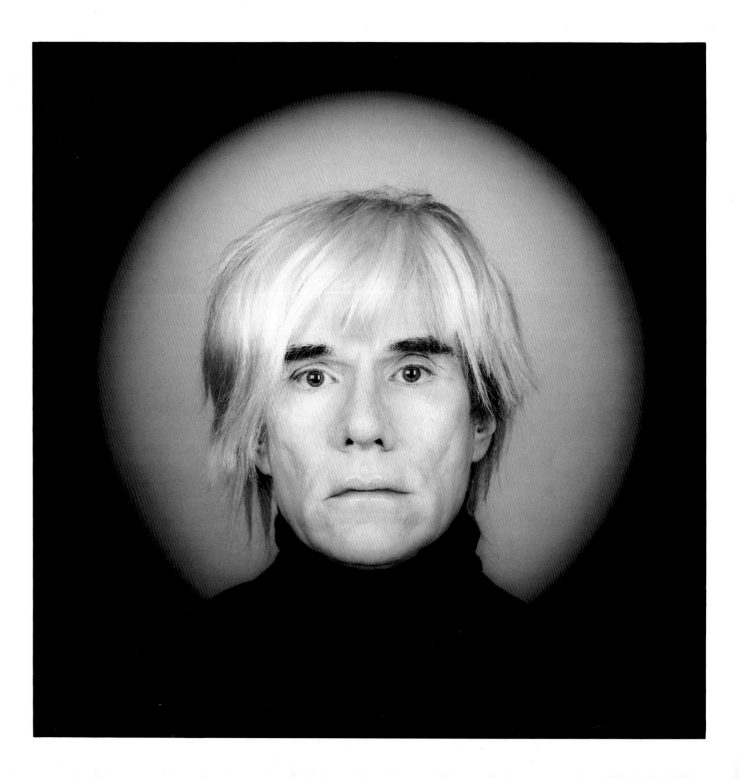

All paintings are directly or indirectly inspired by things or people around us. I guess this is what you call a stereotype. The selection of the images is the most important and is the fruit of the imagination. I generally take a photograph, or a painting and it's just easier that way. I try to do the easiest one so that everyone can understand and relate to what I try to express . . . I like the idea of industrial art. Paint is made industrially . . . so are the brushes, or the canvases. Everything is made industrially today. All the tools we use to create images are made industrially. I do my paintings half mechanically, but I wish I could do it all mechanically . . . I just like to do the same thing over and over again. Every time I go out and someone is being elected President or Mayor or something, they stick their images all over the walls and I always think I do those . . . I always think it's my work. It's a way of expressing oneself! . . . All my images are the same . . . but very different at the same time . . . They change with the light of colors, with the times and moods . . . Isn't life a series of images that change as they repeat themselves?

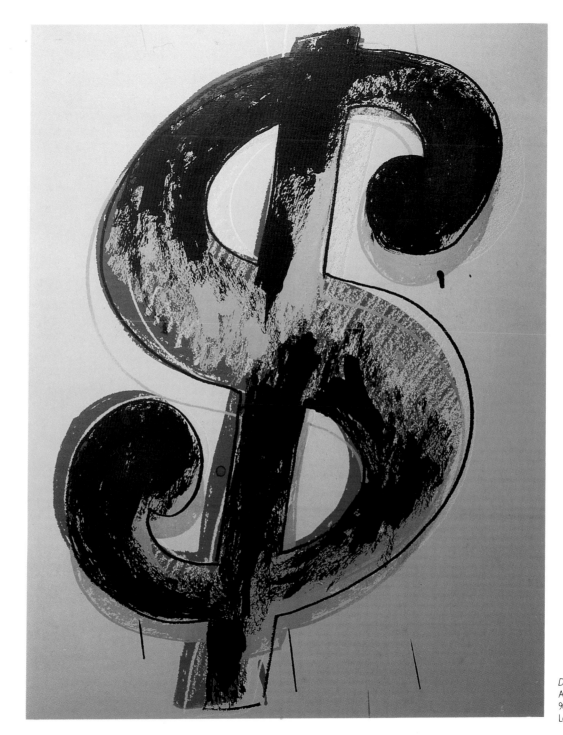

Dollar Sign, 1981
Acrylic and silkscreen on canvas
90 by 70"
Leo Castelli Gallery, New York

111

JACKIE WINSOR

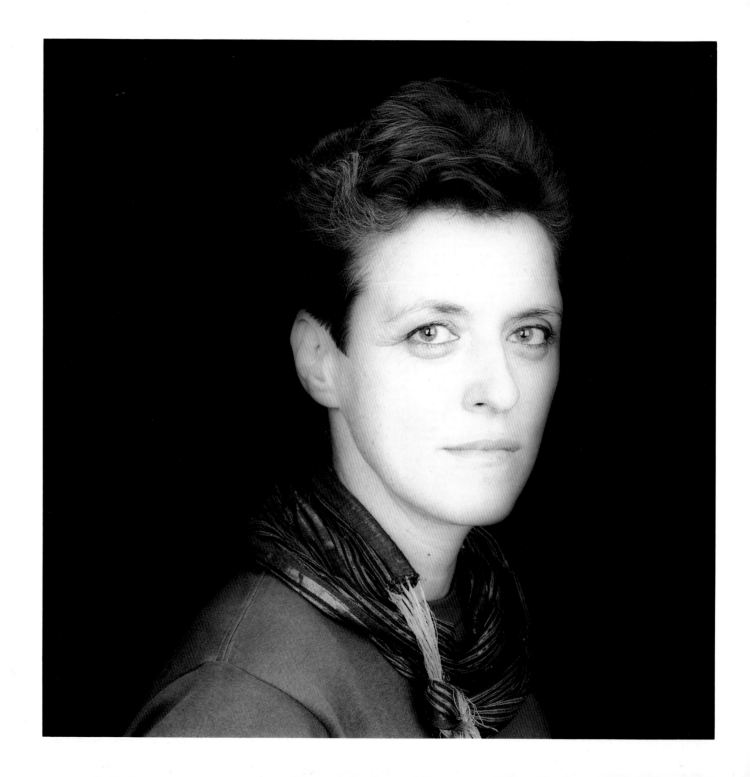

What interests me is how the content quality of a color can equal qualities inherent in other materials that I am using. This sculpture has many fine layers of shades of red painted on the outer wooden frame of the cube with mirrors inset on the six sides and a sphere burned out of its center. I wanted the inside and the outside to equal each other. The inside is the residue of burning; the outside, the sumptuousness of fire. My attention at the moment is in penetrating the anatomy of what content is or might be—to understand the abstract principles that are there. I'm interested in how our contents mirror each other and how you can move parts—parts of abstraction, parts of life. An element I'm working with is fire, in the sculptural, carving-away sense, and the illusion of fire. I'm dealing with the real and the illusions together in one thing.

Interior Sphere Piece, 1985
Mirrored glass, painted wood
31 by 31 by 31″
Paula Cooper Gallery, New York

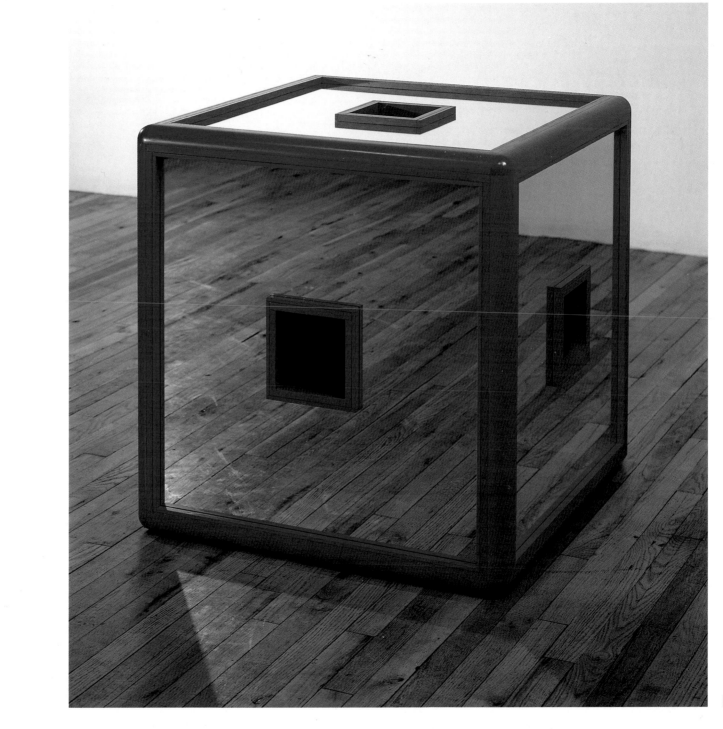

TERRY WINTERS

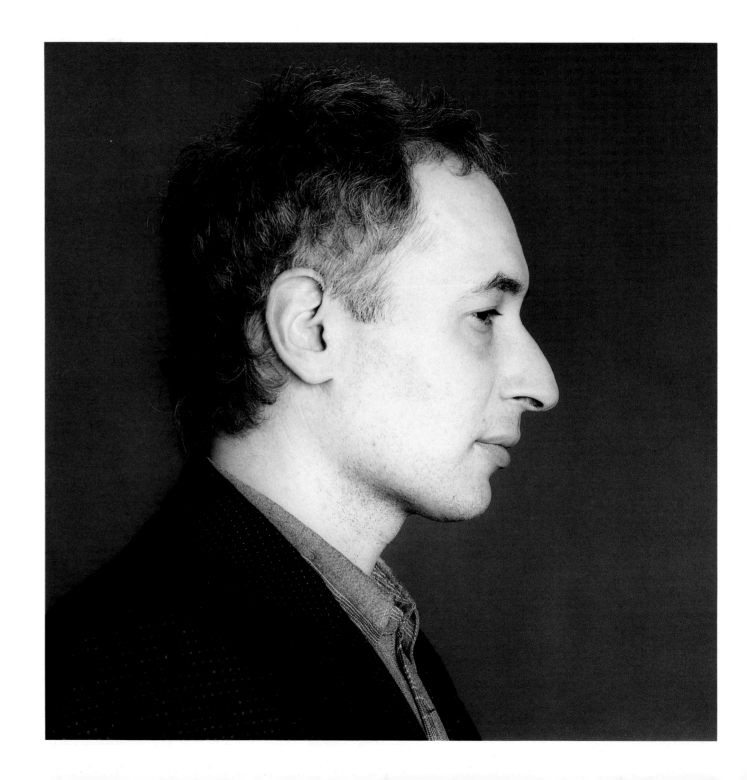

P ainting Notes:
 Optical section. Test pat-
tern. Spectral analysis. Con-
spiracy of circumstance.
Sequence of events. Effects of
conjugation. A painting is a
laminated structure.

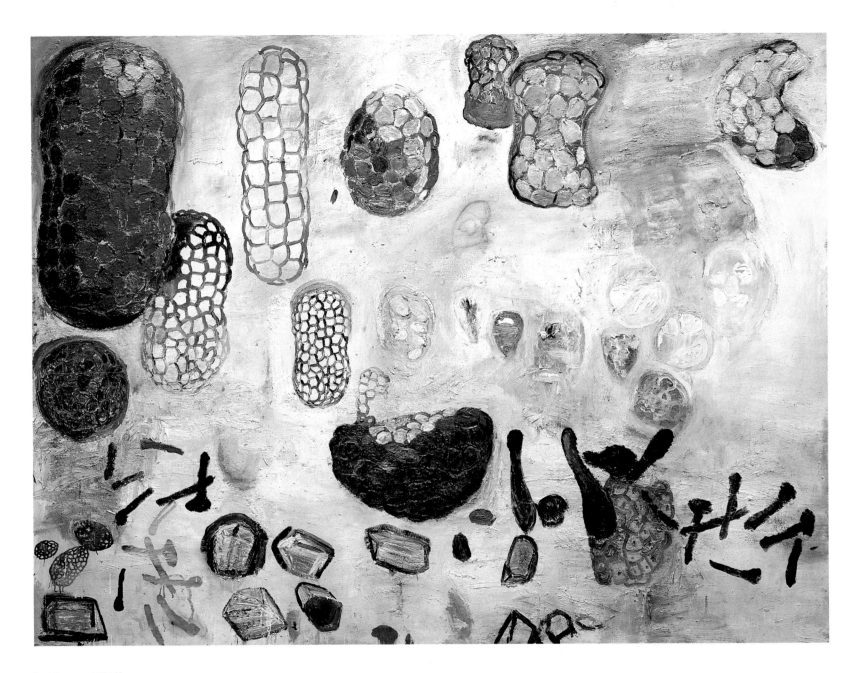

Good Government, 1984-85
Oil on linen
101 by 136"
Whitney Museum of American Art, New York; Purchase,
with funds from The Mnuchin Foundation and the Painting
and Sculpture Committee

115

ARTISTS' NEW YORK REPRESENTATIVES

For more information about the artists presented in this book, contact their galleries or artists' representatives.

Gregory Amenoff
Robert Miller Gallery
41 E. Fifty-seventh Street
New York, NY 10022

Richard Artschwager
Leo Castelli Gallery
420 W. Broadway
New York, NY 10012

Jennifer Bartlett
Paula Cooper Gallery
155 Wooster Street
New York, NY 10012

Lynda Benglis
Paula Cooper Gallery
155 Wooster Street
New York, NY 10012

Louise Bourgeois
Robert Miller Gallery
41 E. Fifty-seventh Street
New York, NY 10022

Louisa Chase
Robert Miller Gallery
41 E. Fifty-seventh Street
New York, NY 10022

Sandro Chia
Sperone Westwater
142 Greene Street
New York, NY 10012

Francesco Clemente
Sperone Westwater
142 Greene Street
New York, NY 10012

Chuck Close
The Pace Gallery
32 E. Fifty-seventh Street
New York, NY 10022

Willem de Kooning
Xavier Fourcade, Inc.
36 E. Seventy-fifth Street
New York, NY 10021

Mark di Suvero
Oil & Steel Gallery
Box 2218
Long Island City, NY 11102

Richard Estes
Allan Stone Gallery
48 E. Eighty-sixth Street
New York, NY 10028

R. M. Fischer
Baskerville + Watson
578 Broadway
New York, NY 10012

Eric Fischl
Mary Boone Gallery
417 W. Broadway
New York, NY 10012

Janet Fish
Robert Miller Gallery
41 E. Fifty-seventh Street
New York, NY 10022

Jedd Garet
Robert Miller Gallery
41 E. Fifty-seventh Street
New York, NY 10022

Leon Golub
Barbara Gladstone Gallery
99 Greene Street
New York, NY 10012

Nancy Graves
M. Knoedler & Co.
19 E. Seventy-first Street
New York, NY 10021

Red Grooms
Marlborough Gallery, Inc.
40 W. Fifty-seventh Street
New York, NY 10019

Keith Haring
Tony Shafrazi Gallery
163 Mercer Street
New York, NY 10012

Bryan Hunt
Blum Helman Gallery
20 W. Fifty-seventh Street
New York, NY 10019

Jasper Johns
Leo Castelli Gallery
420 W. Broadway
New York, NY 10012

Donald Judd
Paula Cooper Gallery
155 Wooster Street
New York, NY 10012

Alex Katz
Marlborough Gallery, Inc.
40 W. Fifty-seventh Street
New York, NY 10019

Robert Miller Gallery
41 E. Fifty-seventh Street
New York, NY 10022

Ellsworth Kelly
Blum Helman Gallery
20 W. Fifty-seventh Street
New York, NY 10019

Robert Kushner
Holly Solomon Gallery
724 Fifth Avenue
New York, NY 10019

Roy Lichtenstein
Leo Castelli Gallery
420 W. Broadway
New York, NY 10021

Robert Longo
Metro Pictures
150 Greene Street
New York, NY 10012

Robert Mangold
Paula Cooper Gallery
155 Wooster Street
New York, NY 10012

Robert Mapplethorpe
Robert Miller Gallery
41 E. Fifty-seventh Street
New York, NY 10022

Brice Marden
Mary Boone Gallery
417 W. Broadway
New York, NY 10012

Malcolm Morley
Xavier Fourcade, Inc.
36 E. Seventy-fifth Street
New York, NY 10021

Robert Moskowitz
Robert Moskowitz
P.O. Box 1610
New York, NY 10013

Elizabeth Murray
Paula Cooper Gallery
155 Wooster Street
New York, NY 10012

Louise Nevelson
The Pace Gallery
32 E. Fifty-seventh Street
New York, NY 10022

Isamu Noguchi
Isamu Noguchi Garden Museum
32–37 Vernon Boulevard
Long Island City, NY 11106

The Pace Gallery
32 E. Fifty-seventh Street
New York, NY 10022

Philip Pearlstein
Hirschl & Adler Modern
851 Madison Avenue
New York, NY 10021

Judy Pfaff
Holly Solomon Gallery
724 Fifth Avenue
New York, NY 10019

James Rosenquist
Leo Castelli Gallery
420 W. Broadway
New York, NY 10012

Susan Rothenberg
Willard Gallery
29 E. Seventy-second Street
New York, NY 10021

David Salle
Mary Boone Gallery
417 W. Broadway
New York, NY 10012

Kenny Scharf
Tony Shafrazi Gallery
163 Mercer Street
New York, NY 10012

Julian Schnabel
The Pace Gallery
32 E. Fifty-seventh Street
New York, NY 10022

George Segal
Sidney Janis Gallery
110 W. Fifty-seventh Street
New York, NY 10019

Richard Serra
Leo Castelli Gallery
420 W. Broadway
New York, NY 10012

Joel Shapiro
Paula Cooper Gallery
155 Wooster Street
New York, NY 10012

Cindy Sherman
Metro Pictures
150 Greene Street
New York, NY 10012

Andy Warhol
Leo Castelli Gallery
420 W. Broadway
New York, NY 10012

Jackie Winsor
Paula Cooper Gallery
155 Wooster Street
New York, NY 10012

Terry Winters
Sonnabend Gallery
420 W. Broadway
New York, NY 10012